THE OREGON COAST
PHOTO ROAD TRIP

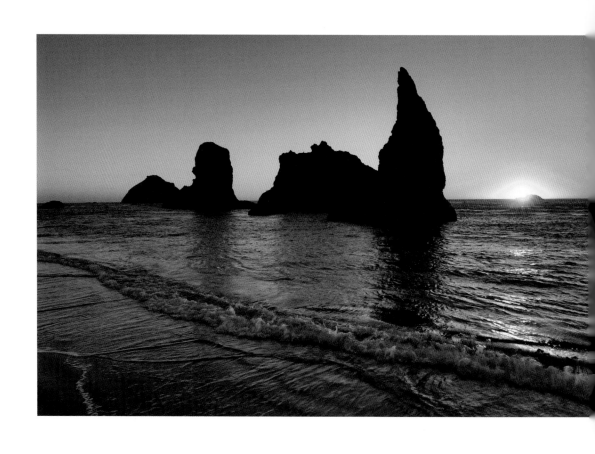

THE OREGON COAST PHOTO ROAD TRIP

HOW TO EAT, STAY, PLAY, AND SHOOT LIKE A PRO

RICK AND SUSAN SAMMON

THE COUNTRYMAN PRESS
A division of W. W. Norton & Company
Independent Publishers Since 1923

For information about permission to reproduce selections from this book,
write to Permissions, The Countryman Press, 500 Fifth Avenue, New York, NY 10110

For information about special discounts for bulk purchases, please contact
W. W. Norton Special Sales at specialsales@wwnorton.com or 800-233-4830

Manufacturing by Versa Press
Book design by Anna Reich
Production manager: Devon Zahn

The Countryman Press
www.countrymanpress.com

A division of W. W. Norton & Company, Inc.
500 Fifth Avenue, New York, NY 10110
www.wwnorton.com

978-1-68268-061-2 (pbk.)

10 9 8 7 6 5 4 3 2 1

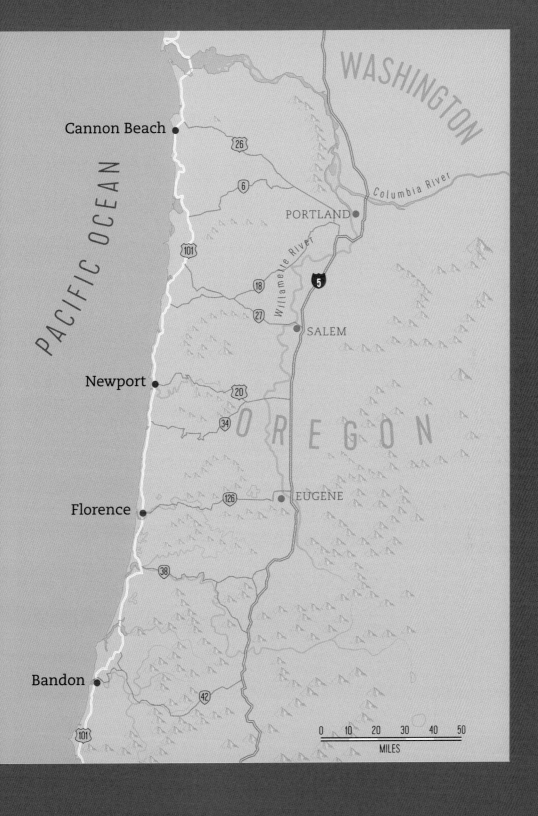

WASHINGTON

Cannon Beach

PACIFIC OCEAN

Columbia River

26

6

PORTLAND

101

Willamette River

18

5

27

SALEM

Newport

20

34

OREGON

Florence

126

EUGENE

38

Bandon

42

101

0 10 20 30 40 50
MILES

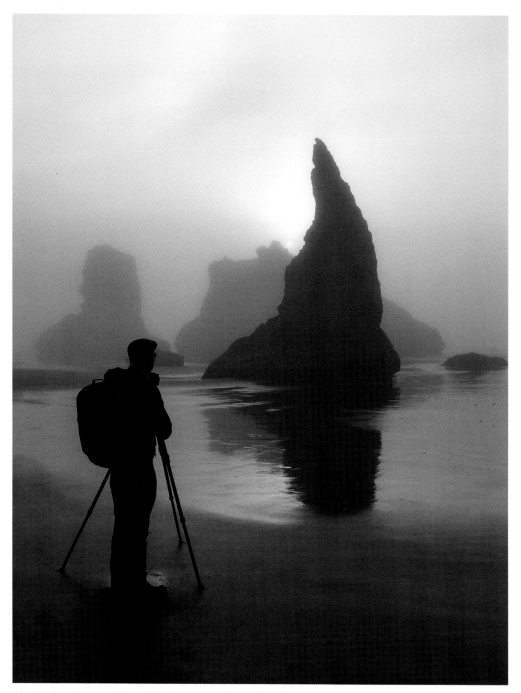

Alex Morley photographing at Howling Dog Rock, Bandon *Photograph by Dianne Morley*

DEDICATION

This book is dedicated to our good friend—and an amazing photographer—Alex Morley. Had it not been for Alex, this book, and the five Oregon Coast photo workshops that we co-led with Alex, would probably never have happened. Here's the story.

Before I knew Alex, he was a participant in one of our Bosque del Apache, New Mexico, photo workshops. At our welcome dinner, we were sitting at opposite ends of a long table in a bustling Mexican restaurant. Before our meals arrived, Alex was showing the photographers sitting around him some of his Oregon Coast photographs on his iPhone. He had taken the photographs he was showing over the course of several years with his digital SLR camera.

When I glanced down at the other end of the table, a super-colorful photograph (of what turned out to be some sea stars and anemones) grabbed my attention.

I literally jumped up and scooted down toward Alex and asked him about the photographs. He explained that he lived in Oregon and that the photographs had been taken on his beloved Oregon Coast.

A year later, Alex and I were co-leading photo workshops to one of the most photogenic places on the planet.

So Susan and I give a big thank you and a big hug to our good friend Alex Morley. You and your photographs have made a huge impact on our lives and on the lives of many others. We are honored to call you our friend.

See more of Alex's photographs on his website: www.alexmorleyphoto.com. Also follow Alex on Facebook: www.facebook.com/alex.k.morley.

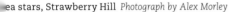
ea stars, Strawberry Hill *Photograph by Alex Morley*

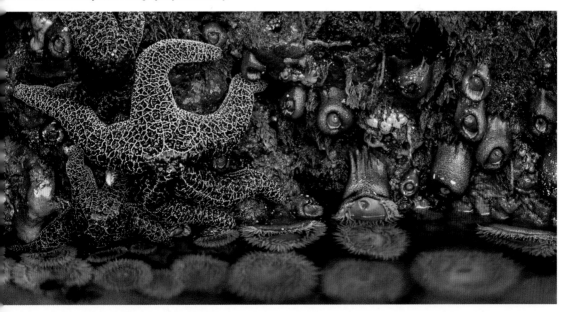

CONTENTS

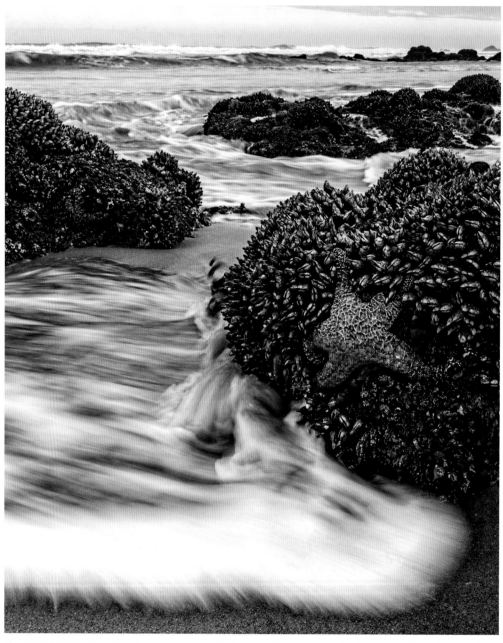

Photographer John Van't Land was one of several photographers who contributed outstanding photographs to this book *Photograph by John Van't Land*

ACKNOWLEDGMENTS

In writing this acknowledgments section, we are reminded of the Beatles song "With a Little Help from My Friends." We sure did have a lot of help from our friends in the making of this book.

Several of our friends contributed their photographs to help make this book the best it could be. These talented individuals are Alex Morley, Gerry Oar, Gary Potts, Steve Casey, Bob Lloyd, Susan Dimock, John Van't Land, and Sarah Cail.

The dedicated staff at Countryman Press also gets a big thank you for transforming our digital files and Word documents into a beautifully presented book and e-book. This team includes Michael Tizzano, Ann Treistman, Devon Zahn, Jess Murphy, and Anna Reich. Bill Ruskin, formerly of Countryman Press and W. W. Norton, also gets our thanks for introducing us to our wonderful publisher.

Our thanks also go to all the photographers who participated in our five Oregon Coast photo workshops. You guys helped make the workshops a ton of fun.

Rick is a member of the Canon Explorers of Light program. All his photographs in this book were taken with Canon cameras and lenses. Rick's friends at Canon—Rob Altman, Danny Neri, Rudy Winston, and Drew MacCallum—get a big thank you for supporting his work.

Rick would also like to thank his friends at the companies that support his creative endeavors: Joe Johnson Jr. and Joe Johnson Sr. at Really Right Stuff (tripods and ball heads), Jenn Sherry at Delkin Devices (memory cards and readers), Graham Clark at Breakthrough Photography (filters), and Larry Tiefenbrunn at Platypod (tripods).

And of course, we thank you, the reader, for your interest in our work and in the Oregon Coast.

Oh yeah, we have one final thank you. It goes to workshop participant Mike "Spike" Ince for finding our car keys inside our car when four other people could not find them. Thanks Mike!

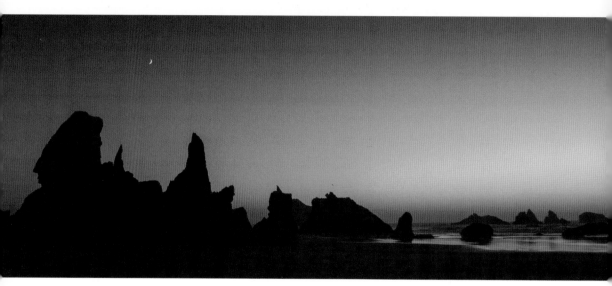

Bandon Beach sunset

PREFACE: OREGON COAST TRIP TIPS

Can't wait to get on the road? We understand. However, before you put your car into drive, we suggest that you check out these road trip tips—developed over the course of our five trips on the Oregon Coast—which will make your trip more enjoyable, productive, and safe.

Planning: Planning is an essential part of any road trip. Sure, it's good to be flexible, but planning your route, looking up drive times between destinations, booking a hotel, and researching dining accommodations will help ensure a smooth ride.

Because you will be on the West Coast, the stage is set for spectacular sunsets. And in the morning you'll have beautiful warm light. Both are great for photography. Plan to leave your hotel with plenty of time to catch the best light.

We usually do our road trips in the spring, summer, and fall, when the weather is relatively warm and the seas are calm. Winter is also a good time to take an Oregon Coast road trip. It's cool and the seas can pick up, which can make for very dramatic photographs of the waves crashing along the shoreline.

A unique aspect of planning an Oregon Coast road trip involves checking the tides, which you can do on your computer through tides.net and noaa.gov, or on your smartphone by using an app such as Tides Near Me or TideTrac. We plan our trips so that low tide coincides with the golden hours for photography—which means that in addition to checking the tides, you will need to know the times of sunrise and sunset. Many online references can help with this. We like sunrise-sunset.org, or you can use the weather app on your smartphone.

Many of the best photo-shooting locations are within Oregon's state parks, recreation areas, natural areas, and scenic viewpoints. We find the park facilities along the coast to be welcoming and well maintained.

Part of planning is to get an Oregon state park pass in advance of your trip. Having the pass will help save time and money, as you will not have to stop and pay for parking at locations that require a permit. There are several types of passes. We buy the twelve-month day-use parking permit ($30 at the time of writing). It's good at all twenty-six Oregon state parks that charge a parking fee and is available for purchase online at oregonstateparks.org.

We book all of our hotels well in advance of our departure and stick pretty much to our planned schedule.

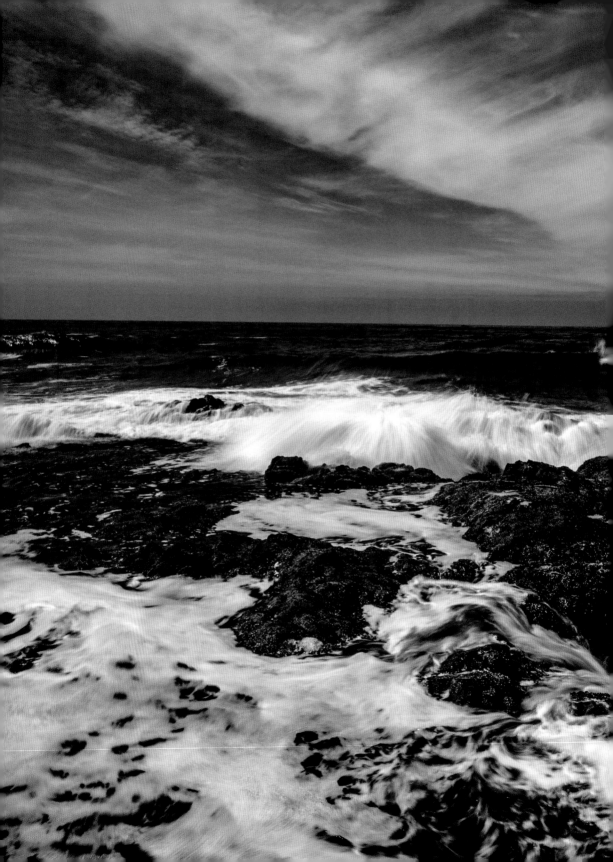

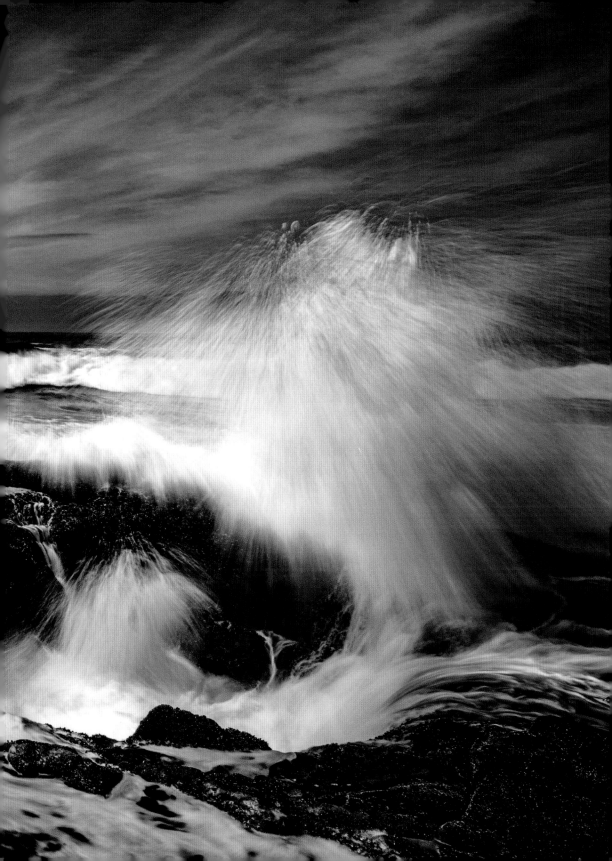

Car: We rent a full-size car for three reasons: comfort, road safety, and space for bag storage, including room in the trunk for camera and computer bags. Keeping bags out of sight helps keep them safe—bags in the back seat can be a target for break-ins.

GPS: Of course, smartphones have great GPS tools. But we prefer using a separate GPS unit for road trips. It frees up your phone so you can do research as you travel, and it prevents your phone from overheating if it is positioned in the sun. Before we leave home, we add most of our destination addresses to our GPS unit. On-site, we add more.

Drivers: We share the driving. This makes the ride more fun, especially for Rick, who likes to take a nap every day! It feels safer to switch drivers. A fresh driver is more alert than a tired driver. The off-duty driver can also help with navigation and with spotting potential photo opportunities!

Water: You don't want to run out of water on the road. We always have several bottles of water in our car and are never thirsty. We pick up a stash of water every time we stop for gas.

Exercise: Sitting for hours on end makes your muscles stiff. Every once in a while, take a break—make a pit stop, get out from behind the wheel, and stretch. Also do some stretching exercises before you get on the road and before you go to bed.

Travel Apps on Smartphones

In addition to the apps we mentioned that track tides, sunrise, and sunset, there are many useful apps to help you find locations and services along the way, and to put on some great tunes while you're on the road from one location to the next.

Here are the apps and services we use to both plan our trips and support our needs while on the road.

- Google Maps—Find locations quickly by address. Plug in your next destination and get the estimated drive time. Also good for finding gas stations on the fly.

- TripAdvisor—Find a list of hotels in the area. Good for planning or for unexpected overnights.

- Yelp—You have to eat. Find restaurants with good food and ambience. Read reviews to identify places that match your personal taste.

- Travel Altimeter—Keep track of your altitude. You might be surprised at how high the road takes you. Drink more water to avoid the effects of high altitude.

- Weather.com—Good for getting a preview of temperatures in upcoming locations. Also a fast way to get sunrise and sunset times so you can capture images in good light.

- Spotify—Streaming music is a great way to enjoy your favorite tunes while you're traveling. You can also browse some great playlists under the "Travel" category. Our favorite playlists include "Heartland Drive," "Family Road Trip," and "Drive Through the Mountains." We pay for premium service so we can download playlists for the road and we don't have to listen to ads.

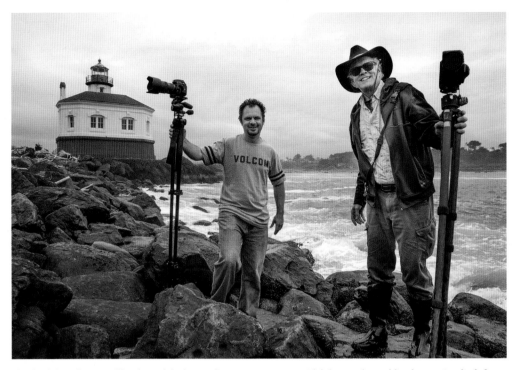

That's Rick at the Coquille River Light in Bandon. As you can see, Rick is wearing rubber boots. On the left is Rick's friend Mike "Spike" Ince, who is not wearing boots and whose socks and feet are soaked in this picture. *Photograph by Alex Morley*

Eating: It's tempting to overeat when you encounter lots and lots of great seafood at the local restaurants. But eating healthy will give you more energy and help to keep your calorie intake low. We keep a box of granola bars in the car so we can enjoy a healthy snack between meals.

Driving: Some of the roads on the Oregon Coast are tree-lined, narrow, and winding. Be alert. Be careful. Check your rearview mirror often. Be respectful of other drivers, and observe the speed limits, too.

Gas: Even though there are plenty of gas stations in the towns you'll be staying in and passing through, we recommend getting gas whenever you can. Or follow my dad's advice: Never leave for a destination with half a tank of gas.

Clothing: Temperatures vary during the day. It can be cool and rainy in the morning and hot and sunny by midday. Dress in layers and peel them off as the day heats up. It's a good idea to pack a hat and sunscreen in your day bag.

wide-brim hat, like the one Susan is wearing in this photograph, and sunscreen are also important accessories. It's easy to get sunburned when you are outside for most of the day. Don't be fooled by an overcast sky; the sun is always working.

Perhaps your most important clothing accessory is rubber boots or NEOS (slip-on, waterproof overshoes available from outdoorphotogear.com). Boots or overshoes will keep your feet dry while you are exploring the shore and tide pools.

AAA: If you drive your own car and do not belong to AAA (the American Automobile Association), we strongly recommend that you become a member. You never know what can happen on the road, and AAA will provide roadside assistance. AAA coverage works when you're driving a rental car, too. It can also get you a discount on hotel rooms; ask about the discount when you book a room or at check-in.

Safety First

Sneaker wave. My friend and Oregon Coast workshop co-leader Alex Morley introduced our group to this term. "Powerful sneaker waves," Alex said, "can sneak up on you and knock you down . . . or, worse yet, pull you into the pounding surf. Always be aware of potential sneaker waves, and never take chances."

Shore area behind the Adobe Resort in Yachats

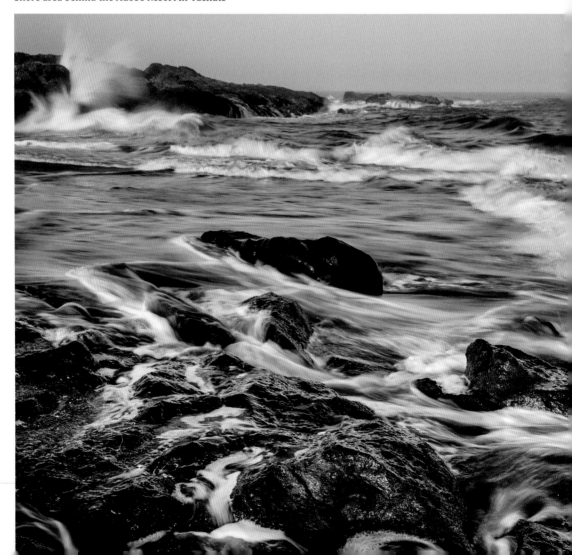

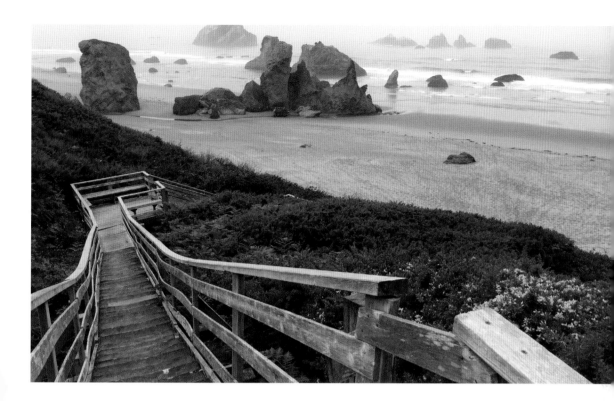

Also be cautious when walking on the algae-covered rocks that are exposed at low tide. These are very, very slippery. Flip-flops and light sneakers are a no-no; hiking boots and sturdy shoes are strongly recommended.

Stairs that lead down to the beach can also be slippery. Hold on to the railing while going up and down the stairs. This is the 142-step staircase across from Sunset Oceanfront Lodging in Bandon. Take a shot of the beach, even if it's overcast, before you head down to the shore.

And of course, safety starts with being in good shape. Because you will be climbing up and down stairs and small cliffs, as well as on rocks, you must be in good shape to get the most out of your Oregon Coast road trip.

We started this section with a photograph of a beautiful sunset on Bandon Beach. This photograph was taken in the same location. Even with the dense fog, we had a great time, making moody photographs and exploring the area in the soft light. So when the fog rolls in, don't roll out. Stay and enjoy the wonders of Mother Nature.

Follow our tips and you will be better prepared for what we feel is one of the best road trips around.

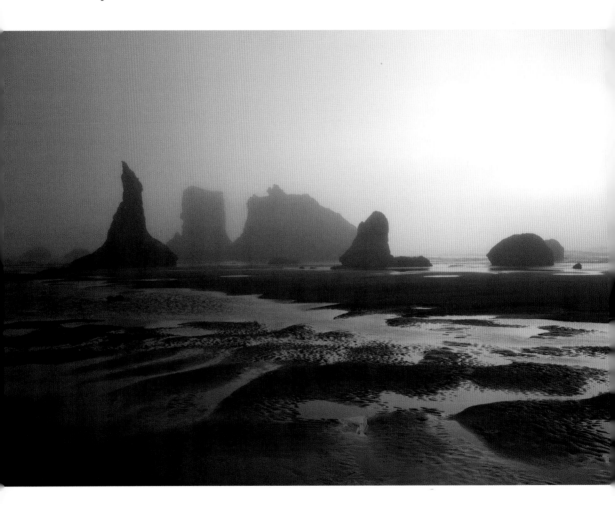

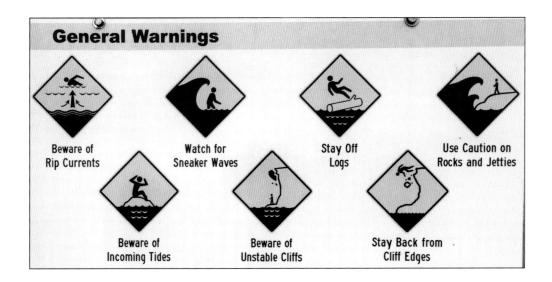

General Warnings

Beware of
Rip Currents

Watch for
Sneaker Waves

Stay Off
Logs

Use Caution on
Rocks and Jetties

Beware of
Incoming Tides

Beware of
Unstable Cliffs

Stay Back from
Cliff Edges

We can't stress safety enough. We photographed this sign at Strawberry Hill. You'll see similar signs at many of the locations we mention in this book.

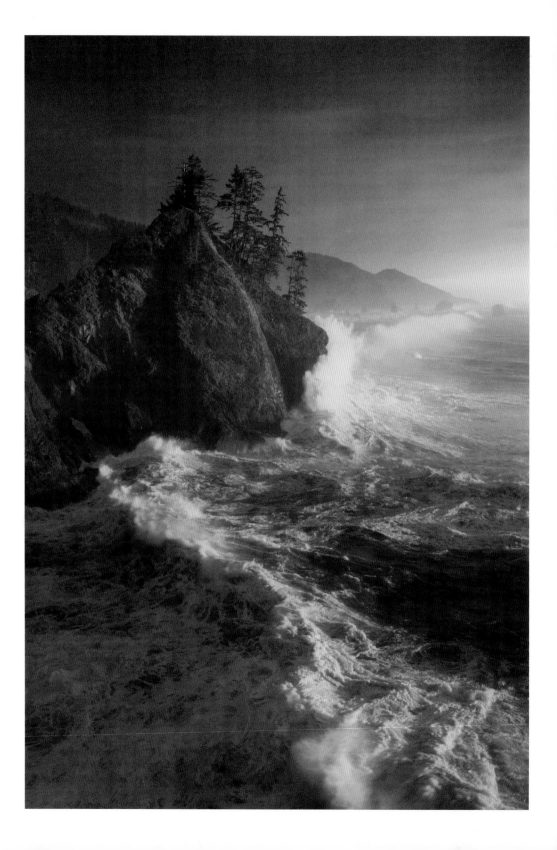

FOREWORD BY NICK PAGE

Simply put, the Oregon Coast is a very special place. Expansive sand dunes, towering basalt cliffs, rain forests, monolithic sea stacks, and iconic lighthouses are just a small part of what makes the area a bucket-list destination.

The Oregon Coast truly is a photographer's paradise. I personally love photographing the way the sea interacts with the dramatic coastline. There is something both exciting and therapeutic about photographing water and waves. No two waves are the same. The Oregon Coast can be peaceful, powerful, tranquil, and quite intimidating—sometimes all in the same day.

The book you are about to read is written by the dynamic duo of Rick and Susan Sammon—two of the most upbeat, positive, and enthusiastic people I have ever met. Their love for the Oregon Coast is matched only by their love of the art of photography—and of teaching.

I've worked with Rick and Susan on the Oregon Coast, and I have to tell you, their enthusiasm for photography, for the region—and for life—is contagious.

This book is filled with great locations, great photographs, and important how-to suggestions—as well as a few "Sammonisms," Rick's easy-to-remember, quick photo tips.

Sit back and enjoy this book about my favorite coastline on this planet, written by two of my favorite humans.

Nick Page

www.nickpagephotography.com

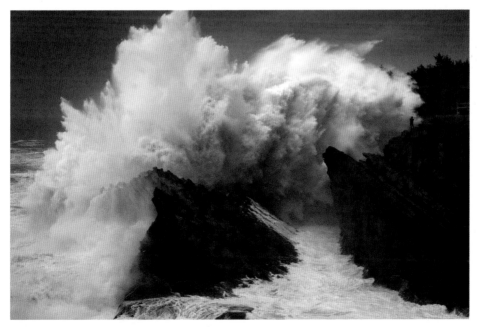

Both photographs by Nick Page

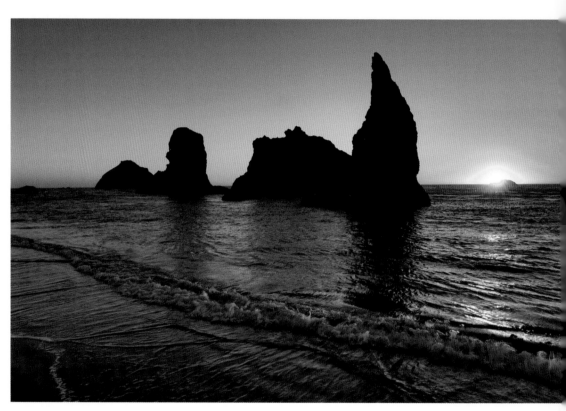

Bandon Beach sunset

INTRODUCTION: WHY DO AN OREGON COAST PHOTO ROAD TRIP?

There's something very special about being by the water. Perhaps it's the sound of the powerful waves crashing on the shoreline, or soft waves caressing the sand and rocks. Maybe it's the way the light—sunlight and moonlight—reflects off the surface of the water, creating sparkling scenes that dazzle your eyes. It could be how at sunrise and sunset, Mother Nature's magical colors, help to paint scenes of wonderment.

And of course, the sights and sounds of seascapes, accented by the sweet smell of sea air, may awaken a primordial feeling that is deeply ingrained in everyone.

The Oregon Coast offers all of the above and more: lighthouses (technically called *lights*) perched on steep cliffs, picturesque fishing villages filled with quaint ships and weathered fishermen, huge rock formations that jut out of the sand, thriving tide pools, a wonderful aquarium in Newport, flocking seabirds and majestic seals, and even a world-class golf course in Bandon. And, last but not least, great seafood!

All these options, combined with easy accessibility and great places to eat and stay, make the Oregon Coast an ideal weeklong (or so) road trip for serious photographers and casual travelers.

Need more reasons to do an Oregon Coast road trip? Here is our top-ten list:

1. Driving from location to location along long and winding roads, with turnoffs for beautiful beaches and picturesque lighthouses, is a relaxing and peaceful experience. Stopping for bites to eat and overnight stays in seaside towns adds to the charm of your road trip. Drive time, away from computers and smartphones, can be think time—time to think about what you have seen and photographed, and to reflect on your experiences.

 Quick tip: Hotels book up early for the summer months, so make your reservations well in advance.

2. You will meet some wonderful people—and characters—on the docks, in the restaurants, at the hotels and motels, and in the shops.

 Quick tip: When approaching strangers for photographs, smile and ask permission first. Promising to send a photograph is also important. Be sure to get the person's e-mail address.

3. Photo opportunities are everywhere, if you seek them out . . . and really look for them.

 Quick tip: Remember, there is a big difference between looking and seeing.

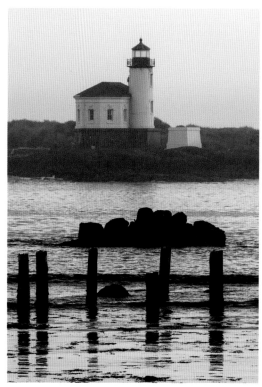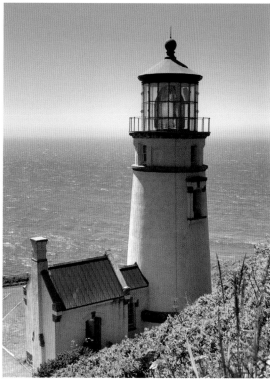

Left: Coquille River Light; Right: Heceta Head Light

4. Celebrate the beauty of one of America's most scenic roads, US Highway 101. Designated the Oregon Coast Highway in this neck of the woods, the 101 is your main road for the whole trip. Enjoy the ride as you travel along the Pacific Coast through mountain passes and coastal towns. Almost all of the major photo locations in this book are easily accessible from the Oregon Coast Highway. Once you reach a location, you'll find parking lots and a path or stairs that lead down to the shore.

 Quick tip: Be extra careful when walking down wooden stairs. Sea spay can make them very slippery.

5. Once you arrive in Oregon, you don't have to get on an airplane to go from location to location until your trip is over. Being self-sufficient and in total control of your schedule is a wonderful and freeing feeling.

 Quick tip: Be sure to lock your car at all locations.

6. Your road trip will not break the bank if you plan wisely. It's a trip that just about everyone can take.

7. You will get inspired to make new pictures because you will be photographing in new locations.

 Quick tip: Get up early and stay out late to capture the best light. Remember—you snooze, you lose.

8. You will also be challenged with weather from time to time, which is a good thing for a photographer. Mist, sometimes very heavy, rolls in and out. This can make for beautiful, moody photographs, but if the mist is too thick, your photo shoot could be a bust. If that happens, just wait for the mist to burn off, or return to the same location at another time.

 Quick tip: Always carry a lens-cleaning cloth to wipe mist, which can make pictures look soft, off your lens.

9. Processing your seascape images—in Photoshop, Lightroom, or on your iPhone—can also play a part in creating original images.

 Quick tip: Back up your pictures in at least two places (accessory hard drive or in the cloud) before you go to sleep each night.

10. You will have a ton of fun exploring the Oregon Coast. We have been to about a hundred countries and we think that traveling on the Oregon Coast is one of the most inspirational photo trips a photographer can make—because of the beauty and photo opportunites you will find.

aside streets along the Oregon Coast are filled with color. Early risers avoid crowds.

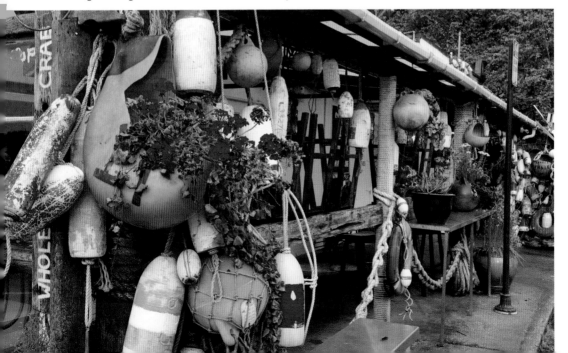

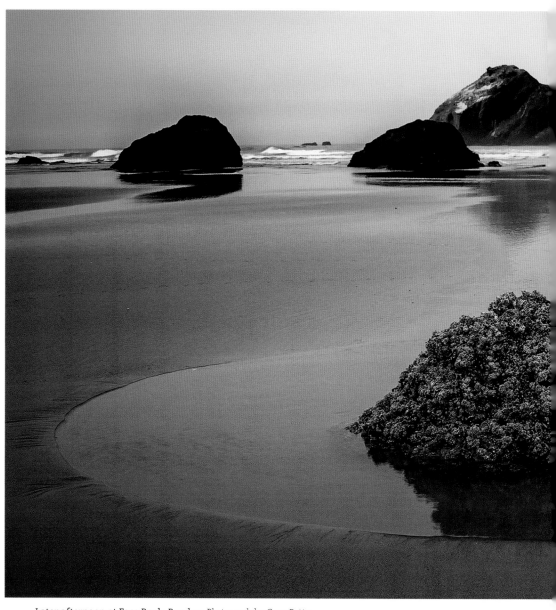

Later afternoon at Face Rock, Bandon *Photograph by Gary Potts*

As an aside, Route 66 is also a fun-filled trip. So much fun that we wrote a book on our adventure: *The Route 66 Photo Road Trip—How to Eat, Stay, Play, and Shoot Like a Pro.*

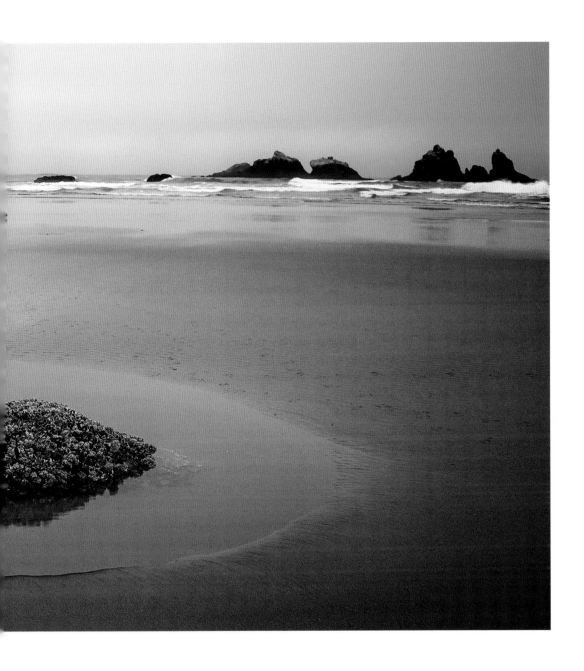

Quick tip: The more fun you put into a road trip, or any vacation, the more fun you and your traveling companion or companions will have.

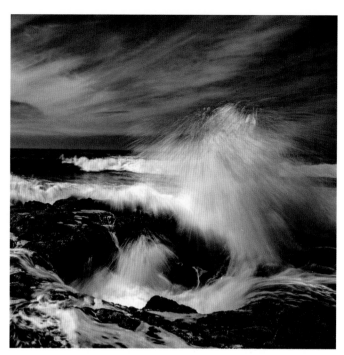

Left: Rick's shot of Thor's Well, Cape Perpetua. Right: Rick photographing at Thor's Well. *Photograph by Sarah Cail*

Using This Book

We wrote this book, as well as our *Route 66 Photo Road Trip* book, for you—someone who wants to enjoy, explore, and document the great outdoors.

In working on this book, we had two goals in mind:

1. We wanted this book to be a planning guide, so you can make the most of your road trip in a limited amount of time.

2. We wanted this book to be your on-site companion, helping you have the most fun and make the best photographs during your time on the road—in this case, on our favorite parts of the Oregon Coast, from north to south, starting in Cannon Beach and ending in Bandon, with stays in Newport and Florence or Yachats.

Our recommended itinerary covers the "prime cut" of the Oregon Coast—a selective section of the coast that is perfect for a weeklong photography road trip.

In planning your road trip, we suggest that you read this book's chapters in order. They were written in the order in which we visited each location, and in the order you

will most likely be visiting each location on a one-way road trip. If you read in order, you will be able to plan your trip from start to finish, getting a good idea of the locations that lie ahead.

If you are new to taking road trips, our tips in the preface will get you prepared for spending time in the car, in hotels, in cities and towns, and in the great outdoors along the shore.

We also recommend that you read our photo tips in the "Jump-Start Your Oregon Coast Photography Experience" section before you travel through the pages that follow. In these tips, Rick talks about making pictures with digital SLR and mirrorless cameras, and Susan offers suggestions for photographing with smartphones.

We hope you enjoy the ride.

—Rick and Susan Sammon

Photograph by Alex Stofko

PART I

JUMP-START YOUR OREGON COAST PHOTOGRAPHY EXPERIENCE

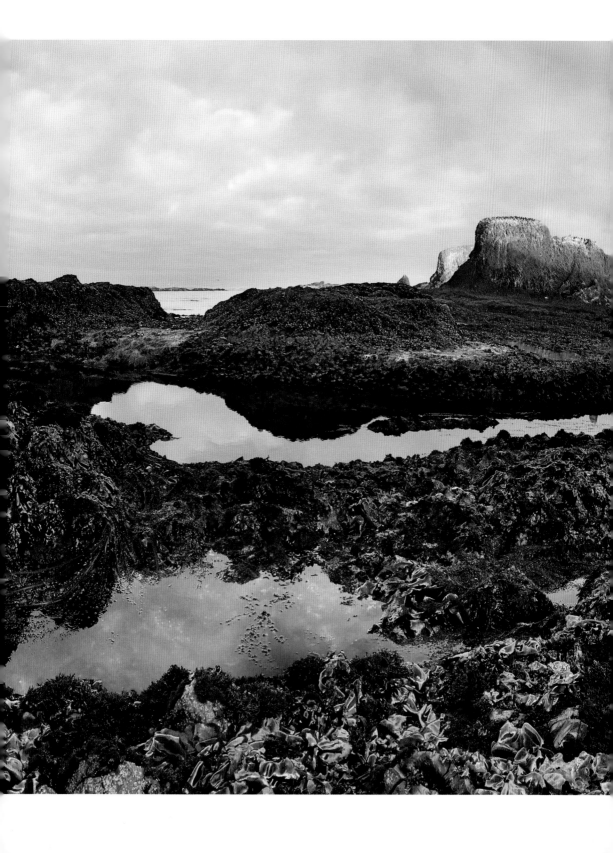

RICK'S QUICK OREGON COAST PHOTO TIPS—
FOR DIGITAL SLRS AND MIRRORLESS CAMERAS

Exploring the Oregon Coast is a magical experience—an experience that, through photographs, you can relive again and again and share with others.

And when it comes to photographs, there is a big difference between a snapshot and a great shot—a photograph that captures the mood and feeling of a scene, the most important elements in any image.

In this section, I'll share with you some quick tips for bringing home images you are proud of, to display on your walls or share on social media.

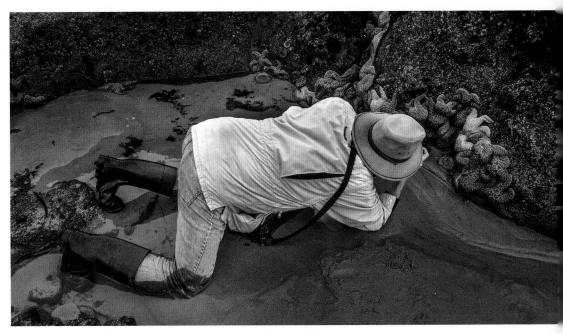

Strawberry Hill *Photograph by Alex Morley*

Use your camera like a drone: The height at which you hold your camera makes a big difference in the final image. That's me in the first picture, getting down low to photograph the sea stars in the following picture. Had I been standing straight up, the photograph surely would have looked like a snapshot. Before you take a picture, move your camera up and down, like a drone, and choose the height that best tells the story of a scene.

When you think you are close, get closer: I used my Canon 15 mm fish-eye lens to capture all the sea stars on this huge mussel-covered rock. The image makes an impact for two main reasons: the subjects are interesting and colorful, and I was photographing very close, maybe about two feet from the rock. Getting closer does not always make a better picture, because negative space can be nice, too. But give it a try and see if your image looks more dramatic from a closer perspective.

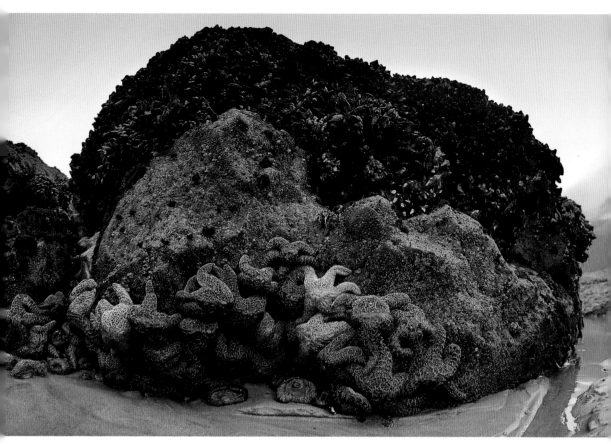

Strawberry Hill

Slow it down: For creative seascape photographs with silky-looking water, you need two essential accessories: a neutral-density (ND) filter or set of filters and a sturdy tripod.

ND filters reduce the amount of light entering your camera, allowing you to use slow shutter speeds—from 1/4 second to several seconds or minutes—even on bright days. You will need a sturdy tripod to steady your camera during long exposures.

I used a shutter speed of eight seconds to create the glass-like water effect in the photograph on page 40.

Variable ND filters let you dial in the light-reducing effect, usually from eight to ten f-stops. Fixed ND filters come in different grades—three, six, ten, and twenty f-stops. I use only fixed ND filters, made by Breakthrough Photography. Why? Because variable ND filters can produce a dark band or circle in the image when you're using a wide-angle lens. Sure, a set of fixed ND filters is more expensive than a variable ND filter, but the quality and the results are worth it.

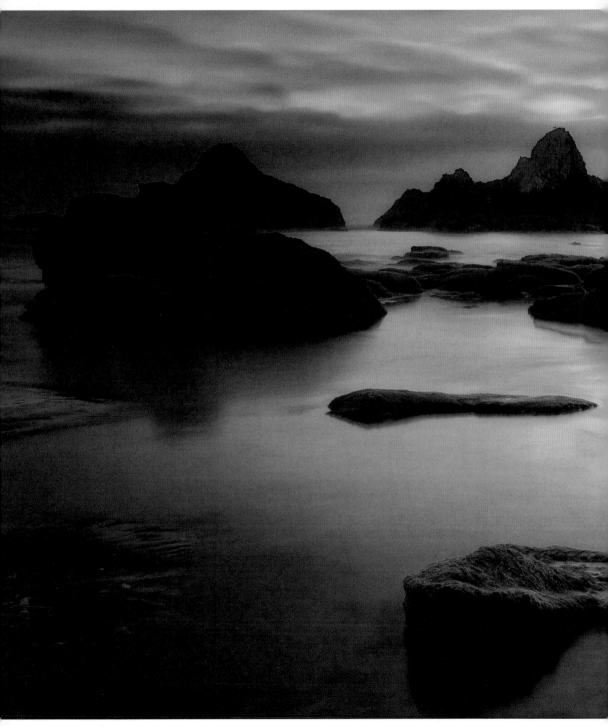

Seal Rock

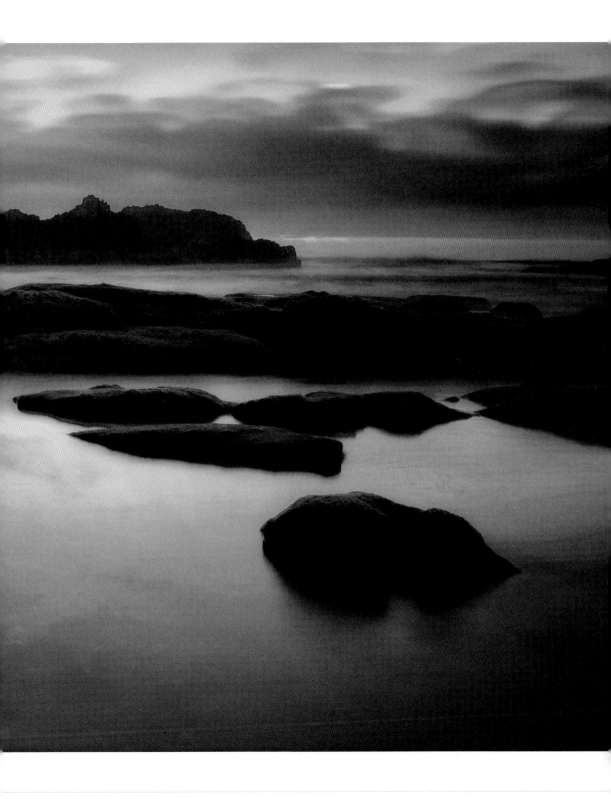

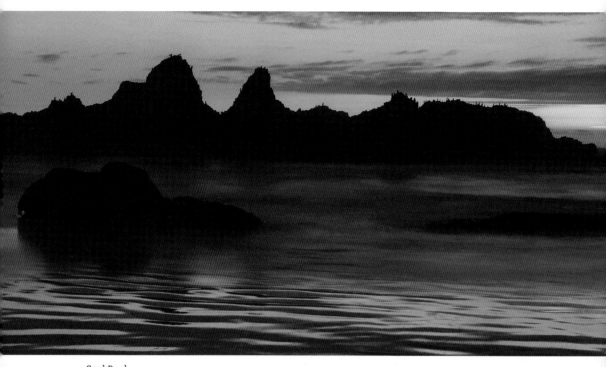

Seal Rock

Here I used a shutter speed of five seconds to blur the moving water.

So, what's the best slow shutter speed to use? It depends—ideal shutter speed varies based on how fast the water is moving, how close you are to the water, and your desired effect. My advice is to photograph the same scene using different shutter speeds, and choose your favorite when you get home.

The four photographs on page 43 illustrate the difference between fast and slow shutter speeds. The two pictures on the left were taken at 1/125 second, while the pictures on the right were taken at 1/4 second. You may like all four images, as I do; both fast shutter speeds and slow shutter speeds can create images that have an impact.

Here's a tip that applies to these photographs, and to all the seaside locations in this book: keep a microfiber cloth handy to wipe salt spray, which can make pictures look soft, off your lens. Also, keep your camera in a plastic camera cover to protect it from the elements when needed.

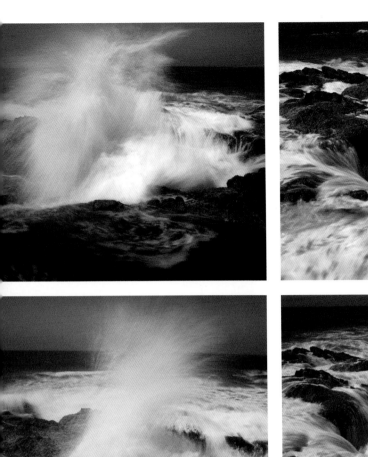
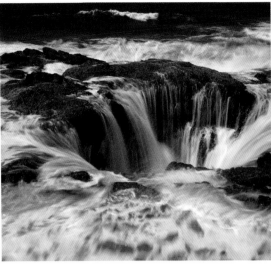
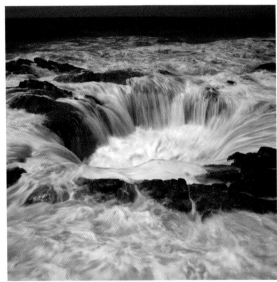

Thor's Well

Yaquina Bay Light

Perfect a pano: You will find many sweeping seascapes as you travel along the Oregon Coast. These extra-wide views are perfect for panoramas. This image is the result of five photographs stitched together with Lightroom's Panorama feature, which automatically combines several images into a panorama.

When taking pictures for a panorama, you'll need to follow these recommendations:

1. Remove all filters.

2. Set your camera to manual exposure, and set the exposure for the brightest part of the scene.

3. Hold your camera vertically.

4. Take your first picture at the right or left of the scene. Move your camera so that the next image overlaps with the previous image by about one-third.

5. Repeat, keep the horizon line level, until your set of images is complete.

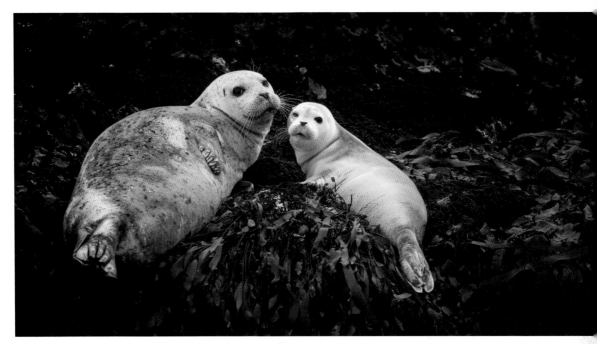

Strawberry Hill

Pack a telephoto lens: In addition to offering breathtaking scenic opportunities, which you'll capture with your wide-angle lens (I recommend a 16-35 mm lens), the Oregon Coast is also home to a wonderful array of wildlife. For close-ups of the animals, you'll need a telephoto lens. This photograph of a mother seal and her pup was taken with my Canon 100-400 mm lens, which is my favorite wildlife photography lens. You'll need that 400 mm focal length because in many cases you can't get close to the animals.

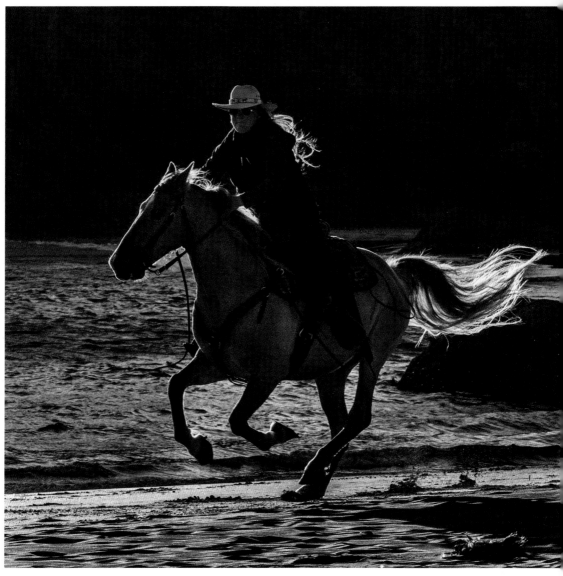

Bandon Beach

Expose for the highlights: Notice the beautiful rim light, and the detail in that light, around this horse and rider. You see the detail because I set the exposure for the highlights. To achieve this, activate your camera's highlight alert or overexposure warning. Take a shot. If you get what are called blinkies—the warning light blinking, which indicates overexposed areas of a scene—reduce your exposure a little at a time until those nasty blinkies go away.

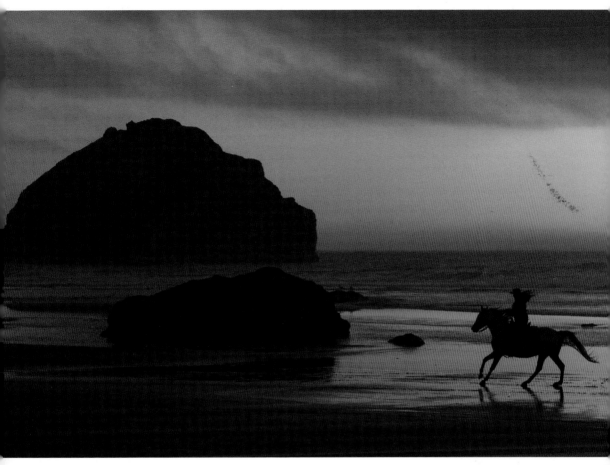

Bandon Beach

Silhouette secrets: Silhouettes are fun and creative, because they have a sense of mystery and wonder. To prevent overexposed highlights, set your exposure compensation to −1 to start.

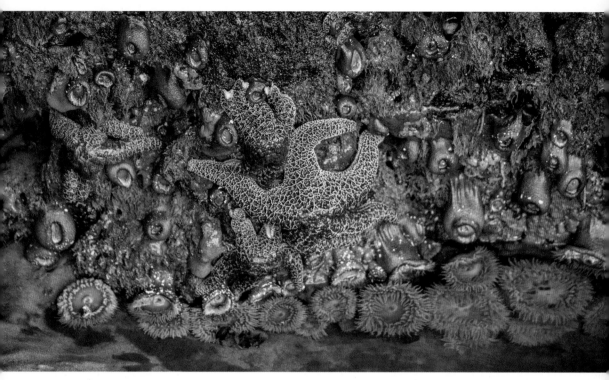

Strawberry Hill

Make cool close-ups: You will find cool close-up opportunities at tide pools as you explore the Oregon Coast. Check the tides using a tide app, so you are on location at low tide, when the sea stars and anemones are out of the water.

You don't need a true macro lens for close-ups unless you want a full-frame shot of a very small subject. A high-quality wide-angle lens takes excellent close-up shots. All my close-ups in this book were taken with my Canon 24-105 mm IS lens.

Keep in mind that when you're photographing subjects close-up, depth of field is reduced. Therefore, use a small aperture, f/11 or f/16, if you want to get the entire scene in focus.

You can reduce reflections by using a polarizing filter. Holding a black umbrella over the area is also a good way to reduce reflections.

Explore HDR: High dynamic range photography is needed to capture the entire brightness range of a scene with very high contrast. Basially, you take a series of pictures at different exposures—at, over, and under the recommended exposure setting—and then use an HDR program to merge the images into one dramatically exposed image.

Here are the seven exposures I took to produce my HDR image of Devil's Punchbowl.

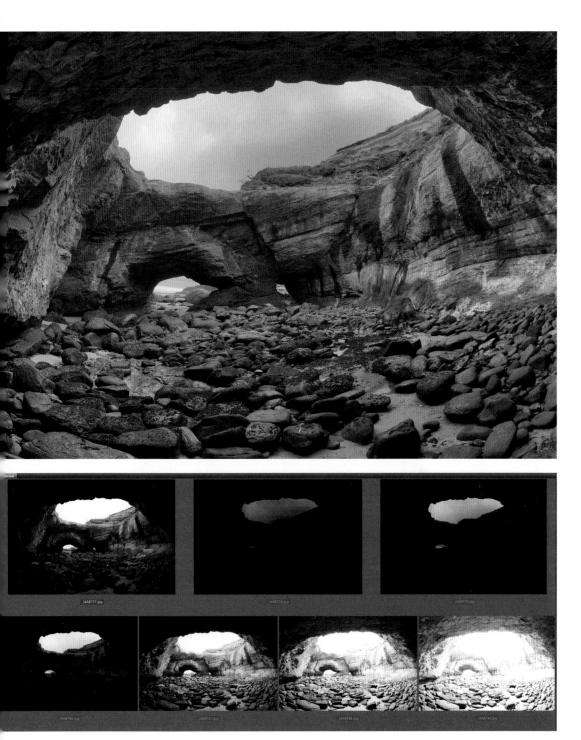

Devil's Punchbowl

Newport

Photograph people: You will meet some wonderful people and interesting characters—fishermen, beach walkers, restaurant owners, and fellow road warriors—on your travels along the Oregon Coast. Pictures of these people will add a human element to a slide show or online gallery.

Our number one tip for photographing people on the Oregon Coast is to take an environmental portrait—that is, a picture of the person in his or her surrounding environment. A tight head shot could have been taken in your backyard. The subject's environment helps to tell his or her story.

When photographing people, keep in mind that silence is deadly. Keep a conservation going by asking questions. When photographing a fisherman, for example, ask about his boat, how long he stays out, his catch, and so on.

Remember to take pictures of yourself with your spouse or traveling buddy: If no one is around to take a shot, set up your camera on a tripod and use the self-timer to capture a special moment, as we did here in Florence.

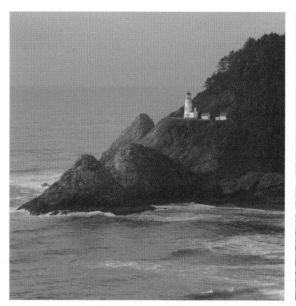 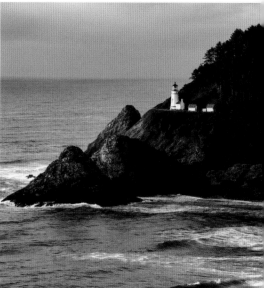

Heceta Head Light

Have no fear—Lightroom and Photoshop are here: The weather on the Oregon Coast is constantly changing. It may be foggy for a while, and then the sun will come out to brighten up your day—and vice versa.

If you don't have time to wait for the best weather, enjoy the mood of the scene and keep taking pictures even if they look dull and flat. Post-processing will come to the rescue.

Lackluster pictures can be transformed into beautiful images with the help of Photoshop, Lightroom, and other image-processing programs, as illustrated by this before-and-after pair of pictures. The transformation is the result of the photo being digitally enhanced by applying Dehaze and boosting the contrast and saturation.

No matter what kind of camera you use, remember—cameras don't take pictures; people do.

The Oregon Coast is known for bodies of water and waves. It's also known for its sand dunes. Take both wide-angle and detail photographs—and look for something you recognize in the patterns created by light and shadows. What do you see in the close-up photograph on the right? Some folks see the figure of a woman. One of our friends saw a guitar.

In the ports along the coast, you will also find old fishing vessels, and in Newport you will find a marine junkyard of sorts, Foulweather Trawl, where I took this photograph of a patch of rust on an old piece of commercial fishing equipment. I see a sailing ship at sunset. What do you see? As we will demonstrate throughout this book, photo opportunities really are everywhere—if you look for them.

The ever-changing weather of the Oregon Coast is illustrated by these photographs of Bandon Beach, taken just hours apart. In general, you should always, always check the weather. It's also a good idea to plan your road trip so you can return to a location if the weather looks as though it will change. Even if the weather's bad, enjoy the moment. Take a fun shot to bring back a memory of a great road trip.

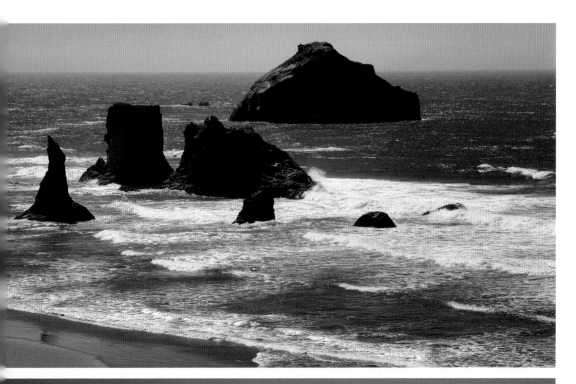

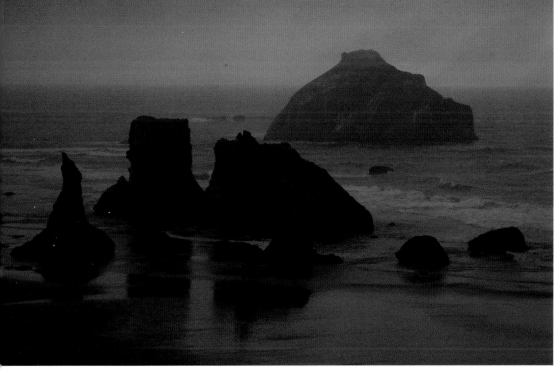

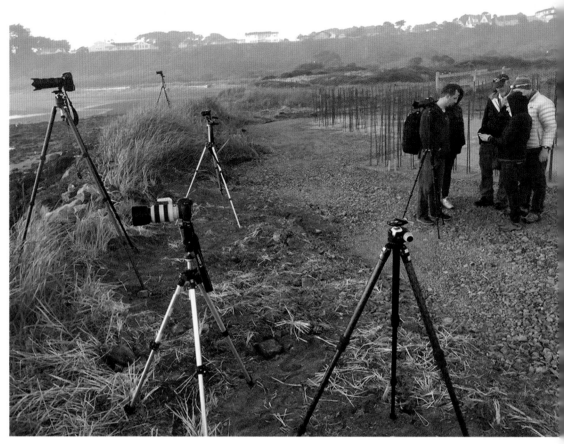

Bandon

I love digital SLR and mirrorless photography, and processing my pictures in Lightroom and Photoshop, but I also love the images that Susan produces with her iPhone. You'll see her work in the next section. For now, here is a shot of Susan teaching iPhone photography to some of our Oregon Coast photo workshop students. It's kind of funny that all the cameras on the tripods are abandoned.

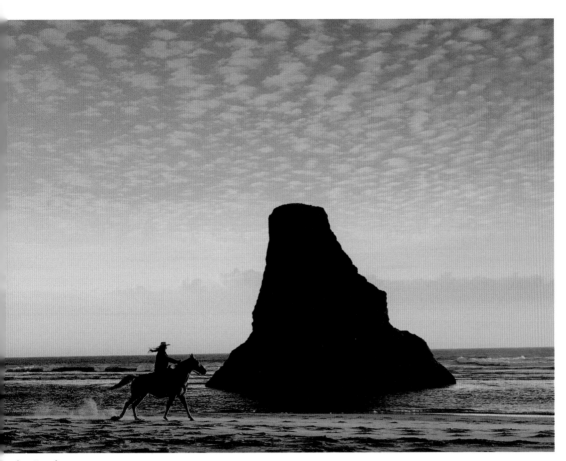

andon Beach

Here's one of Susan's iPhone-enhanced images. She used the Distressed FX app to add the clouds to the clear sky. Very cool.

SUSAN'S PHOTO TIPS—
FOR SMARTPHONE CAMERAS

Do you like to travel light with photo gear? Well, here's some good news: your smartphone is a great camera for an Oregon Coast sojourn. Locations along the coast at beaches, harbors, and scenic parklands present perfect photo opportunities for these small yet powerful cameras.

As we have mentioned throughout this book, the parks and recreation areas on the Oregon Coast are sometimes gray due to rain and fog. To add pizzazz and variety to dull images, I encourage you to experiment with photo apps, which are available for both iPhones and Android phones.

I find that adding effects with photo apps is a joyful and creative process, and it gets my images more attention on social media. The same might be true for you. Yes, some of my iPhone photos have a distinctive post-processed look, but this is my intention. All good!

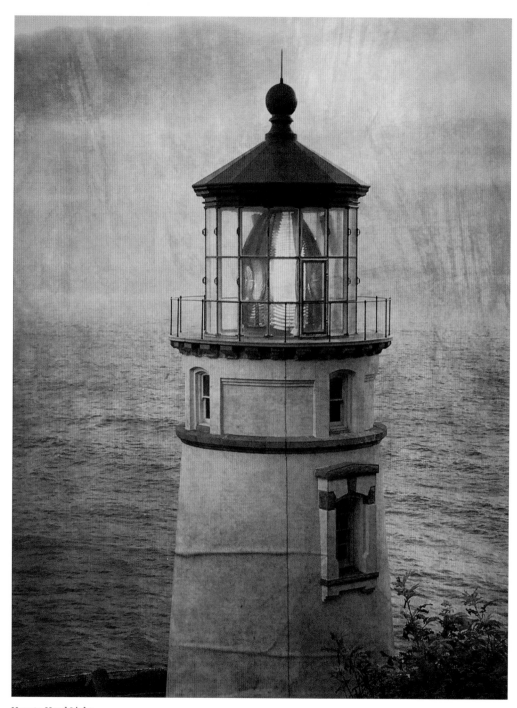

Heceta Head Light

Before we get into adding special effects, let's review a few basics. Make sure your photos are in focus and well exposed by holding your phone steady when taking your shots, and by using your touch screen controls to select focus and exposure before you shoot.

You will find many photo-processing apps in the App Store and on Google Play. To help you get started, I will highlight a few of my favorites. Some are free, such as Snapseed, and others cost a few dollars. At the end of this section you'll see the app icons, to make sure you select the right ones when you shop. All my recommendations are available for iPhones. Some are not available for Androids, but you can find apps that offer similar effects.

Add Light with LensFlare

Lighthouses are some of Oregon's most iconic photo subjects. They are very commanding perched on cliffs overlooking the ocean. And they can look even better with dramatic and colorful light beams added. Use the app LensFlare to add different types of light: anamorphic, spherical, sun flares, and streaks. Select the light type under Effects. Use your fingers to move the beam into place; then pinch to adjust the size. Here I added a spherical beam with a "Sci-Fi" filter to make Yaquina Light pop.

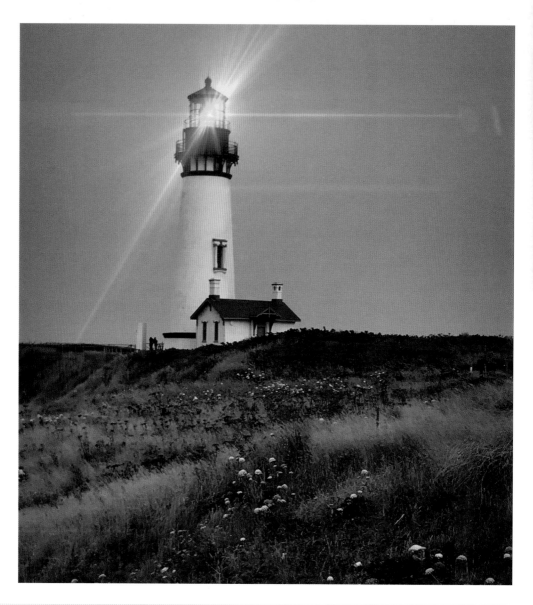

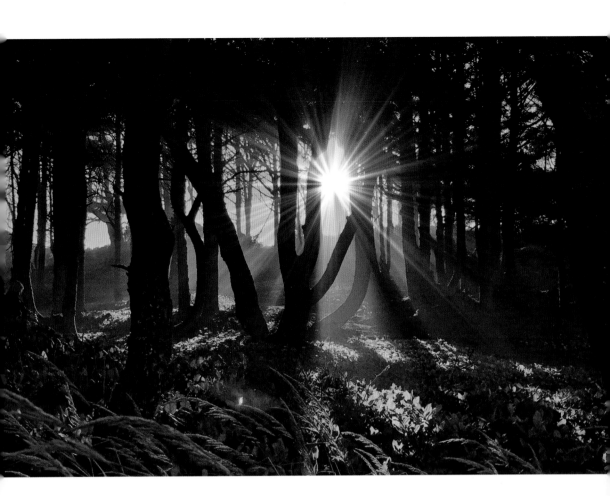

When you're shooting into the sun, LensFlare can add a starburst effect similar to the one you'd get using a full-feature camera shooting at f/16 or f/22. To add light beams coming through the trees, I selected a sun flare effect and adjusted the color using the Edit sliders.

Add Clouds with Distressed FX

Sometimes a clear, cloudless blue sky is not the best background for a beach scene. To break up the uniform color and make your image more compelling, try adding a cloud effect using the app Distressed FX. I use this app to add texture and to boost color using the original overlay pack. After you purchase the app, you can buy more options. The Heavens overlay pack can add wonderful clouds to any photo, such as the "Waving Cloud" effect I added to my Bandon Beach image. In this case, I was going for a realistic look.

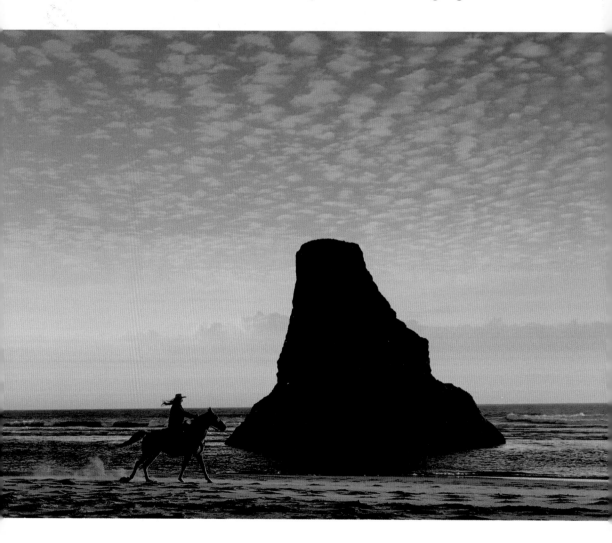

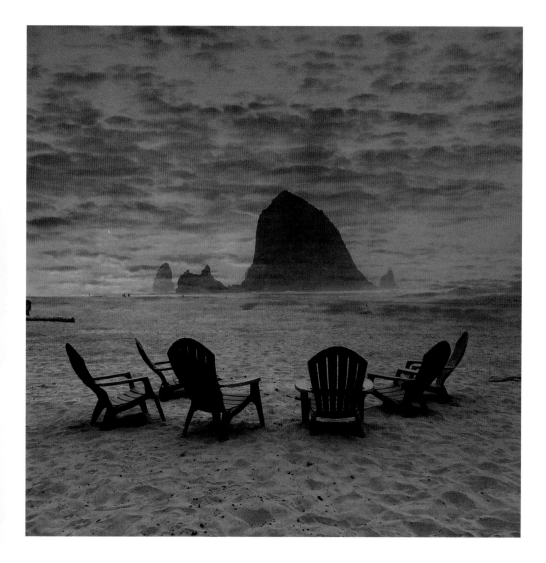

Colorful clouds can spice up a quiet beach scene. To add drama to my Cannon Beach photo, I used the "Lanky" effect, also found in the Heavens pack of Distressed FX, which creates a dreamy-looking image.

Add texture with Brushstroke and Distressed FX

Nothing transforms a photo like texture. Make your photos look more artistic by using photo apps to add color and texture—just like a painter!

The Brushstroke app is very easy to use. Select a photo and then test the presets in different brushstroke categories, including oil, washed, and natural. Keep clicking until you see something you like. I chose a "Simple"-style brushstroke for this photo of the Coquille lighthouse in Bandon.

Coquille Lighthouse, Bandon

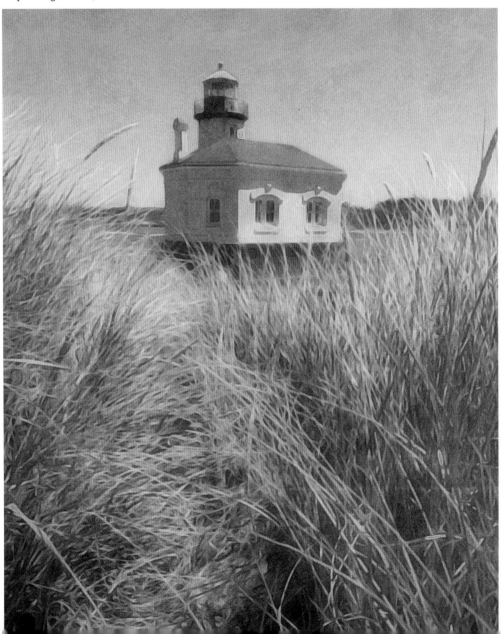

ape Kiwanda

I decided to go for a more abstract look with a beach scene at Cape Kiwanda. Here I used the Distressed FX app with the original overlay pack. I selected "Lora" on the upper slider for a two-tone color enhancement and "Blithe" on the lower slider for dramatic texture. This app makes the kayaks more visible; they were lost in the original gray-day image.

Try Vintage with Snapseed

Good old Snapseed, my favorite overall photo-processing app, is a powerful tool. For my travel photos, I often use the Vintage options on my people shots. Pick an image, select Vintage, and click through the presets until you get a look you like. I selected a sepia tone and then added a curved-edge frame to create a postcard-like image of beach fishermen at Cape Kiwanda.

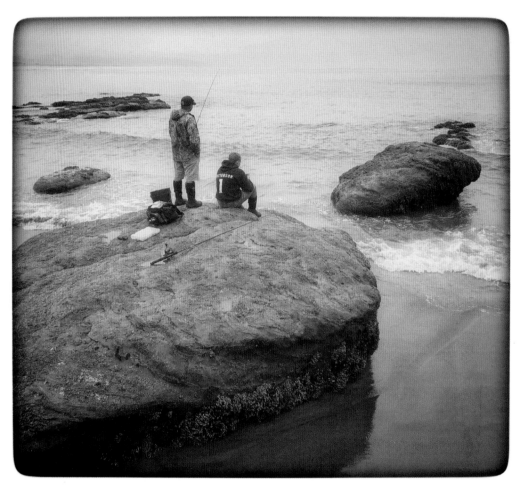

Cape Kiwanda

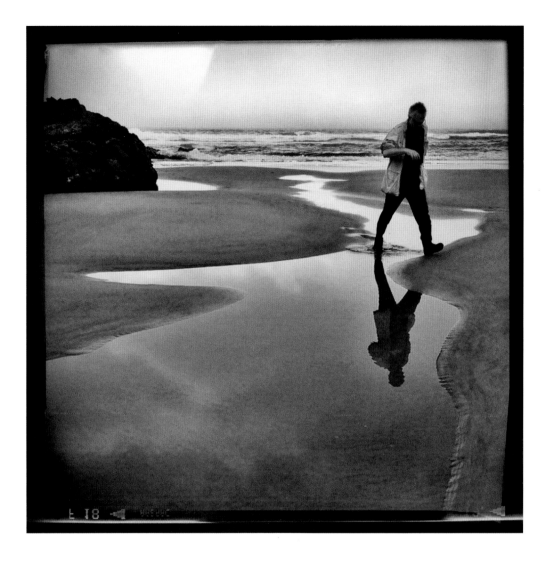

I used a black-and-white effect from the Vintage presets for this shot of Rick, which reminds me of an old Henri Cartier-Bresson photo. To finish the look, I added a grungy frame using the Frame tool.

Try Black-and-White with Dramatic Black & White and Snapseed

Converting color photos to black-and-white images can make them look more dramatic. The app Dramatic Black & White gives you lots of options, including black-and-white, dramatic black-and-white, and infrared. The day I took this photo of the Spouting Horn, it was very sunny and everything was evenly lit. I selected one of the dramatic black-and-white presets to increase contrast and make the splashing water look more powerful against the rocks.

Spouting Horn

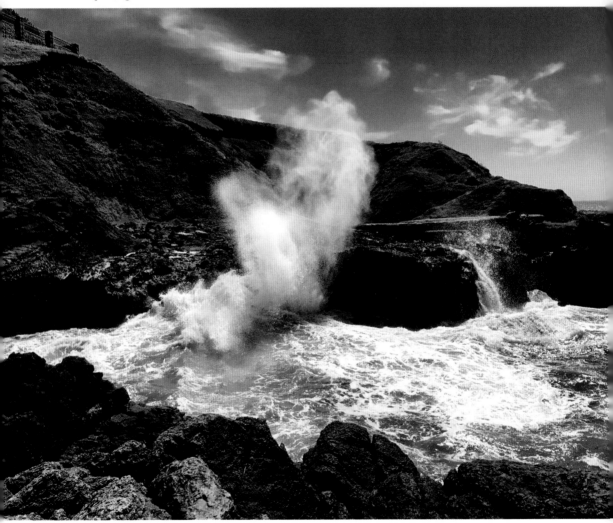

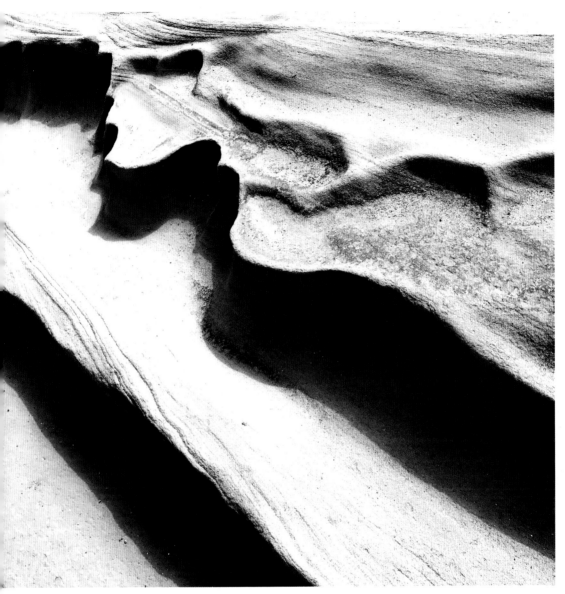

hores Acres State Park

Snapseed offers two tools for creating monochromatic effects: black-and-white and noir. Subjects with a lot of texture, like rocks and fishing boats, look really good in black-and-white. Here I used a subtle black-and-white preset to enhance the shadows of the rocks along the cliff at Shore Acres State Park.

Go Bold with Photo Wizard

As you can see from the images in this section, I enjoy transforming my iPhone photos by enhancing the color and texture. I also like to use special effects to take photos to another level of creativity. The following images show examples of these effects.

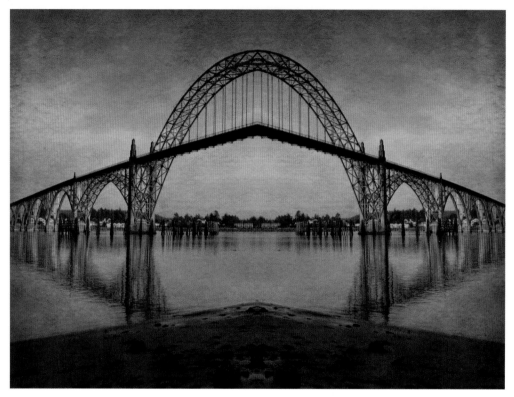

Yaquina Bay Bridge

The app Photo Wizard has some wild and crazy effects. You can experiment a lot with this app. To begin, open a photo in Photo Wizard and select Fx Effects to access more than forty presets. The "Symmetry" effect works well on structures like buildings, docks, and dams. I think it makes the Yaquina Bay Bridge soar to new heights.

If you select Filters in Photo Wizard, you will find another twenty presets to jazz up your photos. I chose the "Motion Blur" filter for this dramatic photo of Rick on the beach in Oregon. This effect looks good on a single subject positioned in the center of the frame.

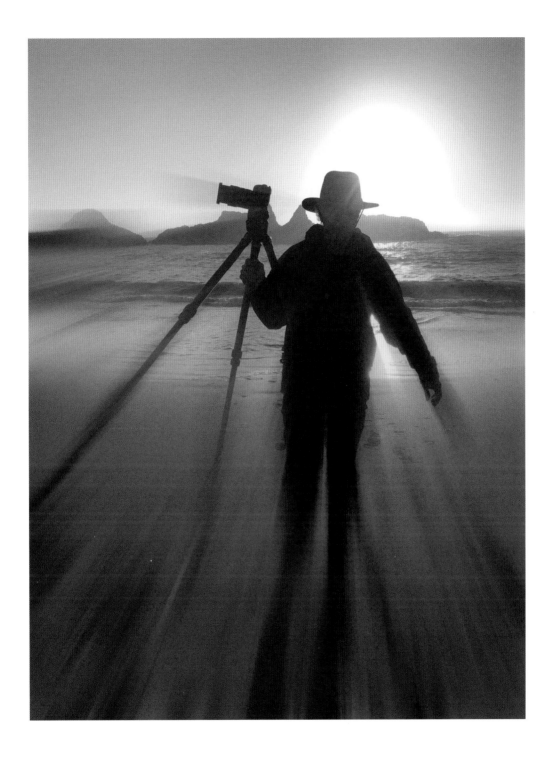

A Closing Thought

Shooting and processing iPhone photographs can be a satisfying creative outlet. It is for me. The good news is that if you have your phone with you, you have a camera and a way to process photos anywhere. I find that I enjoy post-processing my images when I'm on the road, waiting for a plane, or when I have a quiet moment at home.

Sometimes I get lost in the process and keep working on an image, using several different apps to edit it. When I'm done, I cannot always remember all the steps. No worries! That is the case in the image of the Heceta Head Light that opens this section. I don't know how I got there, but I love the result.

I encourage you to download a few of these apps and experiment with your own work. Maybe you will find a new way to express your creative side, and stumble on a photo style that makes you smile.

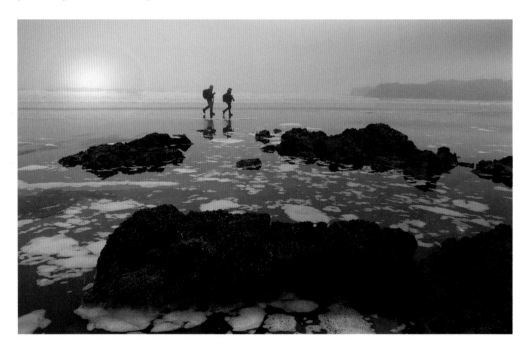

Brushstroke ⁴⁺

Turn photos into paintings
Code Organa

#70 in Photo & Video
★★★★★ 4.8, 3.4K Ratings

$3.99 · Offers In-App Purchases

Distressed FX ⁴⁺

Photo Filters & Textures
We Are Here

★★★★★ 4.8, 2.5K Ratings

$0.99 · Offers In-App Purchases

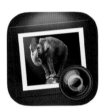

Dramatic Black & White

Powered by JixiPix
JixiPix Software

★★★★☆ 4.6, 54 Ratings

$2.99

LensFlare Optical Effects

BrainFeverMedia

★★★★★ 4.8, 186 Ratings

$2.99

PhotoWizard-Photo Editor

Pankaj Goswami

★★★★☆ 4.5, 149 Ratings

Free

Snapseed ⁴⁺

Google, Inc.

#42 in Photo & Video
★★★★☆ 4.0, 2.2K Ratings

Free

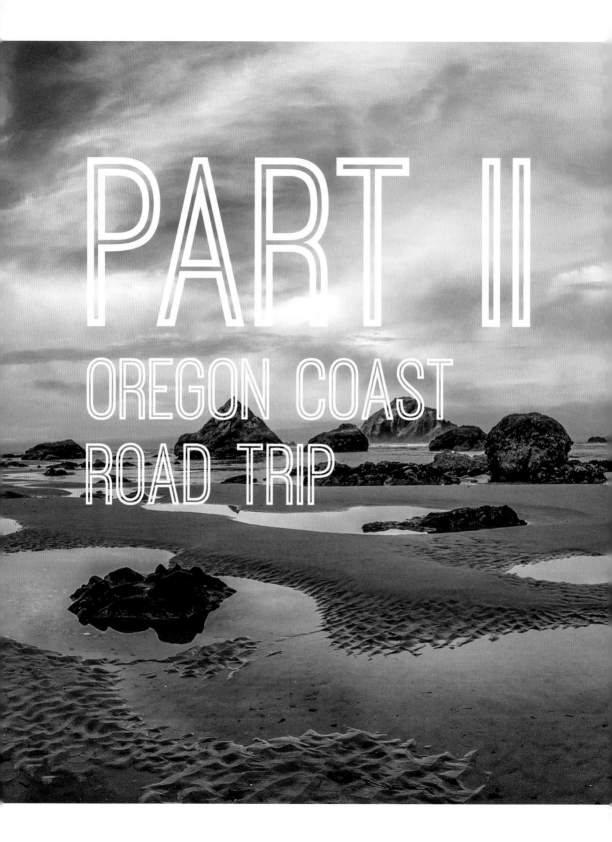

PART II

OREGON COAST ROAD TRIP

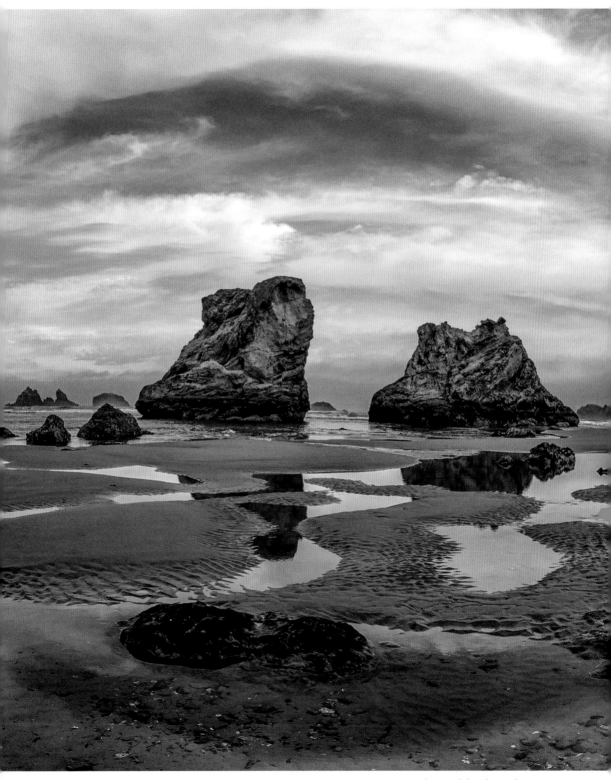

Photograph by Alex Morley

Chinook

Columbia River

Wreck of the *Peter Iredale* ■

Astoria ●

Warrenton ■

Sunset Beach ■

Seaside ■

[101]

[202]

Ecola State Park ■

Cannon Beach ●

■ Hug Point State Recreation Site

Arch Cape ■

[53]

[26]

Rockaway Beach ●

Garibaldi ■

Cape Meares ■

[6]

Oceanside ●

Netarts ■

Tillamook ●

[101]

PACIFIC OCEAN

Sandlake ■

Tierra del Mar ■

Cape Kiwanda ■ Pacific City ●

0 5 10 15
MILES

CANNON BEACH—
HOME BASE FOR THE NORTHERN COAST

One of Oregon's most popular spots, Haystack Rock, draws beach lovers and photographers alike to Cannon Beach. It is a commanding visual landmark; a 235-foot-high basalt dome presiding over a beautiful sandy beach. But this bustling coastal town offers more than just a rock; Cannon Beach has an abundance of galleries, shops, and restaurants as well.

We recommend that you start your photo road trip here—on a high note, with photogenic subjects. You'll get a sample of what is in store all along the coast—beautiful beaches, rocky cliffs, great state parks, and the variable weather that can go from gray, overcast skies to golden sunset in a flash.

Expect foggy mornings in the summer and sudden temperature drops along the coast. Don't worry if you forget to pack a sweatshirt; you can always buy one at the colorful shops in town.

Cannon Beach is also a good home base for visiting Oregon's northernmost region, all the way up to the Columbia River. There will be lots of tourist traffic, especially in the summer, as it is just an hour-and-a-half drive from Portland.

In this guide, we focus on points closer to Cannon Beach with reliable photographic opportunities found at Ecola, Fort Stevens, and Hug Point State Parks.

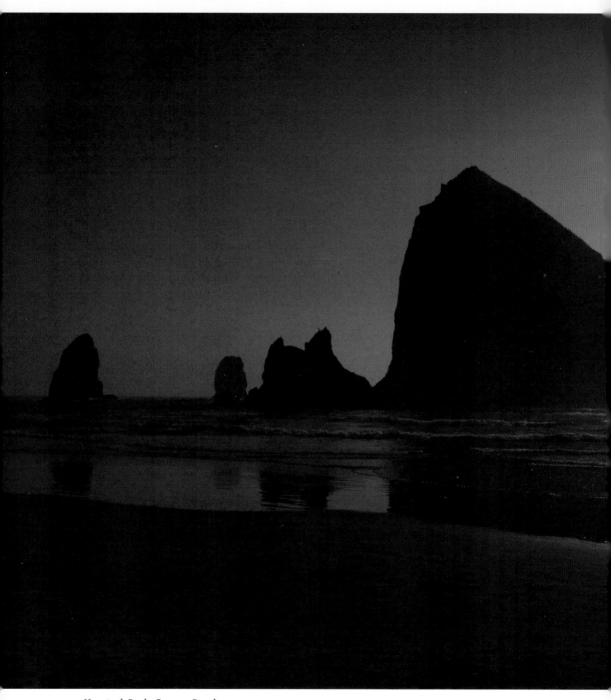

Haystack Rock, Cannon Beach

Cannon Beach and Haystack Rock

As lifelong East Coasters, we enjoy observing and photographing the busy beach activities on Cannon Beach. There are family strollers, lone joggers, dog walkers, sandcastle builders, birders, and fellow photographers. Swimming is not the main draw, for good reason. The Pacific Ocean's temperature here peaks during the summer in the mid-fifties Fahrenheit.

There is public access to the beach at several points. To get to Haystack Rock, park at the Haystack Rock public parking lot at the intersection of Hemlock and Gower. Then cross the street and follow the signs to the beach. We love the private hotel access at the Hallmark Resort Hotel. If you stay at the Hallmark, many rooms overlook the beach and Haystack Rock, so you can monitor conditions for making images right from your room. When you are ready, the hotel's wooden stairs get you to the beach in no time.

It's interesting to note that there are other Haystack Rocks along the Oregon Coast as well. We highlight the one in Cannon Beach, but there is another in Pacific City that you will see from Cape Kiwanda, a couple stops later in your trip.

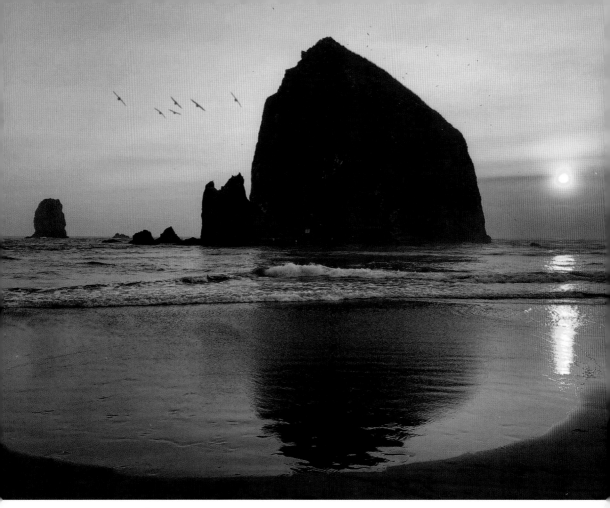

Haystack Rock, Cannon Beach

Photo Tips

Shoot at sunset: We feel that sunset is the best time to photograph Haystack Rock. In the above photo, Rick shot at f/22 with his Canon 24-105 mm IS lens to create the starburst effect.

Capture the mood: Got fog? Go for it! Capture the mood and enjoy the moment. In the top photo on the next page, Susan transformed an iPhone color photo into a beautiful black-and-white image.

Capture the fun: Sure, go for artistic seascape images, but also take fun people shots with your phone, as Susan did in the bottom photo on the next page. She enhanced this image with a Vintage effect in Snapseed.

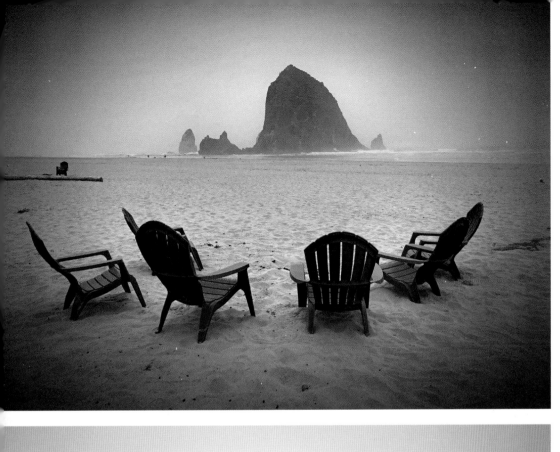

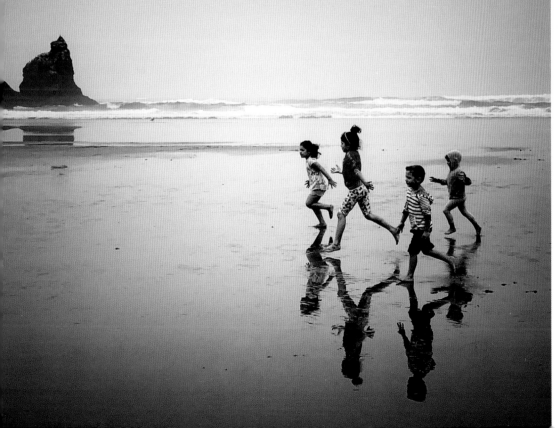

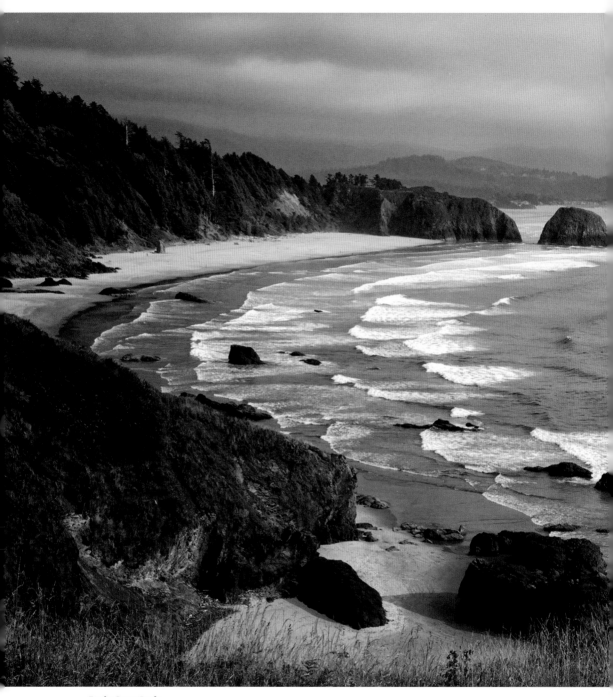

Ecola State Park

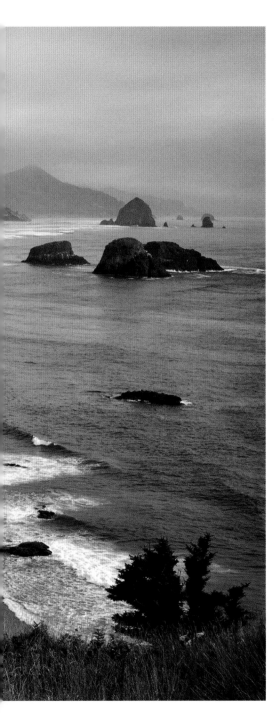

Ecola State Park

Just a short drive north of Cannon Beach, you'll find the entrance to Ecola State Park. This large park offers diverse photographic opportunities, including dramatic ocean vistas, driftwood-filled beaches, and a moody old-growth forest.

You'll need your Oregon state park pass here, or if you don't have one, there's a $5 entrance fee.

For a classic, sweeping view of the Oregon Coast, drive to Ecola Point. Parking is limited and can be a challenge on busy summer days. But braving the crowd is worth it—the view of Crescent Beach is wonderful, especially on a clear day, when you can see Haystack Rock in the distance. It's a good place to work on panoramic images.

Driving to Indian Point takes you on a winding road through a beautiful forest. The trees look magical in the mist and rain, and they provide creative subjects for photography. Finding a place to pull over is the tricky part; parking is not allowed on the side of the road. When you get to Indian Point, you'll find a path leading down to the beach, with opportunities to capture crashing waves and surfers.

Photo Tips

Shake it up: Try this cool effect—move your camera up and down while you are taking a picture, to blur the entire image. By removing some of the sharpness from the scene, you are removing some of the reality. When you remove some of the reality, a picture can, but not always, look more creative and artistic—as illustrated by Susan's iPhone photograph.

Use Dehaze: Photoshop and Lightroom have a feature called Dehaze, which reduces the softening effect of haze in a photograph. Rick applied Dehaze to the opening picture for this section for a clearer view of Crescent Beach. On the next page, you see the before and after effect.

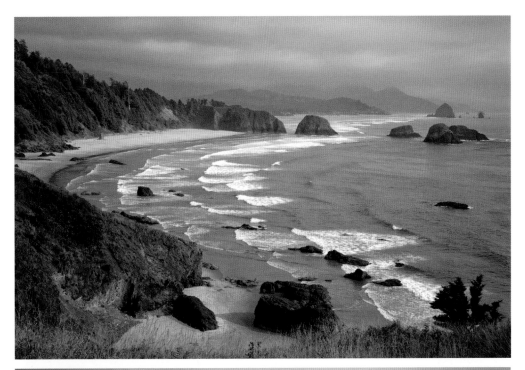

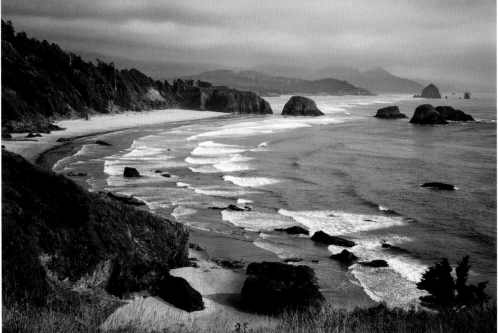

Crescent Beach

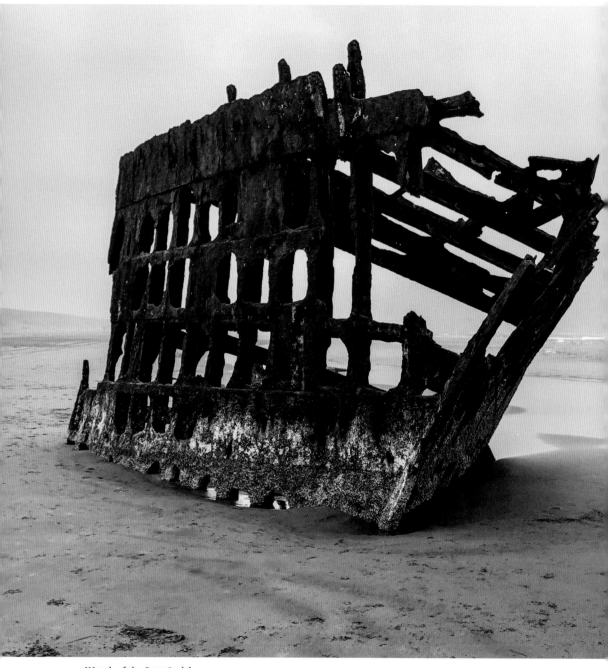

Wreck of the *Peter Iredale*

Wreck of the *Peter Iredale*

The rust-covered skeleton of the *Peter Iredale*, perfectly posed upright on a wide, sandy beach, is located about thirty minutes north of Cannon Beach in Fort Stevens State Park. This park is Oregon's largest state park and offers trails for hiking and biking, historic landmarks, and ocean and river views.

The remains of the shipwreck—a British ship that ran aground in 1906—is a popular stop for photographers, especially at sunset and at low tide. Again, checking the tides in all your Oregon Coast locations will help you get close to photo subjects.

A good idea is to use your GPS to guide you to the park. If you are driving north from Cannon Beach, you'll take US 101 to Oregon Route 104. Look for the signs to Fort Stevens. When you enter the park, pick up a brochure or find a posted map to navigate to the *Peter Iredale* shipwreck.

Fort Stevens State Park

100 Peter Iredale Rd.
Hammond, OR 97121

Photo Tips

Show scale: You might be surprised at the relatively small size of shipwreck. To convey the size of the subject, place a person in the scene, as Susan did by asking Rick to step into the frame. Yes! As usual, Rick is wearing his waterproof boots, which he recommends for all beach photography.

Be creative: You might find yourself at this location in less-than-ideal conditions, with gray skies and many tourists and photographers. If that is the case, embrace the situation: think of it as a good time to experiment with creative image making. Try converting an image to black-and-white, taking silhouettes, and exploring close-ups, as Susan did here with her iPhone.

After-image effects: Believe it or not, Susan took this picture shortly after she took the iPhone photo of Rick that opens this section. She added the color and clouds using Distressed FX, one of her favorite iPhone apps. So the tip is this: When the light is not quite right for you, think about all the creative possibilities—with apps and with Photoshop and Lightroom plug-ins—that await you in post-processing.

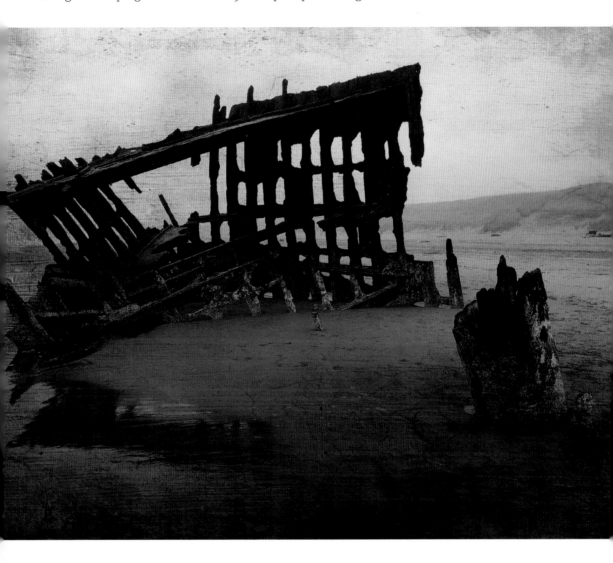

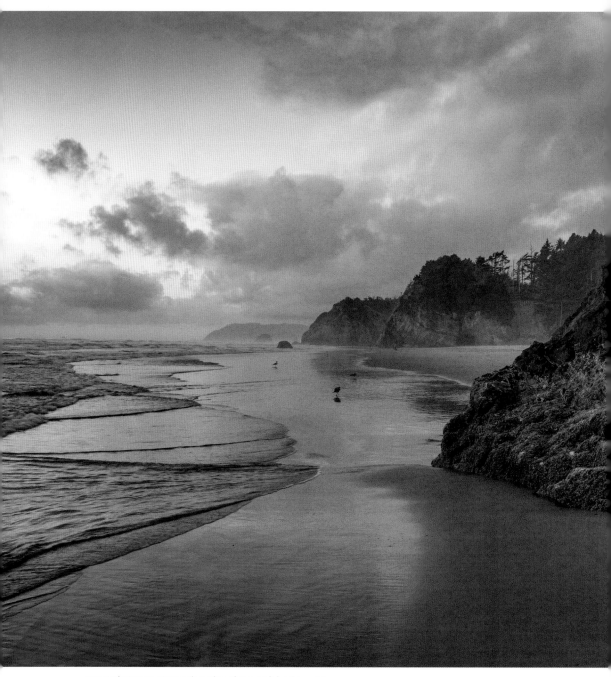

Hug Point State Recreation Site *Photograph by Gerry Oar*

Hug Point State Recreation Site

With a name like Hug Point, this place has to have a story. Before the Oregon Coast Highway was built, early travelers used the beach as a road and had to negotiate around this coastal point at low tide. Later, a roadway was blasted in the rocks to allow stagecoaches and wagons a way around without getting wet. Travelers had to hug the edge of the cliff to stay safe from the ocean. Today, the remains of the rock road can still be seen.

Hug Point is a small site with limited parking. Plan your visit for low tide, and be mindful of the incoming tide, as you could get stranded. There is easy access from the parking lot to a lovely sandy cove with forest above and sea caves below.

Hug Point is just five miles south of Cannon Beach on US 101. Look for the sign after you pass Arcadia Beach State Recreation Site.

Hug Point State Recreation Site
US 101
Arch Cape, OR 97102

Photo Tips

Our friend and a talented photographer, Gerry Oar, took the picture that opens this section. It illustrates three important photo techniques, in addition to the importance of being in the right place at the right time for the best light.

First, everything in the scene is in sharp focus. To achieve that goal, use a wide-angle lens, set a small aperture, and set the focus one-third into the scene. New to setting the focus one-third into the scene? Here's an example: If you were standing at the end of a football field, you'd set the focus at the 33 yard line.

Second, the horizon line is level. When Rick reviews photographs, if the horizon line it not level, it drives him nuts!

Third, we can see nice detail in both the shadowed and highlighted areas of the scene, which is the result of expert processing. Good job, Gerry!

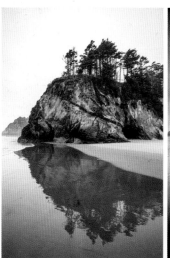 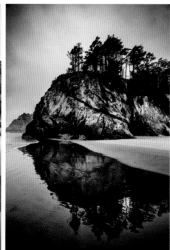 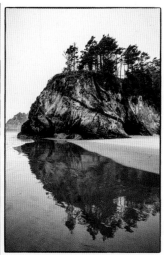

Hug Point

Try converting: When we visited Hug Point, we did not have Gerry's luck with light. The picture on the left is Rick's digital camera shot. To create the black-and-white picture in the middle and sepia-tone image on the right, Rick used a Photoshop/Lightroom plug-in called Silver Efex Pro from Nik Software. In both photographs, the processing enhances the dull sky.

Look for reflections. When you compose your photograph, don't cut off the top of the reflection in the bottom of your frame.

Always look for pictures: Again, the day was very overcast when we visited Hug Point. But Susan saw this interesting rock and moved in for a close-up photograph—and made a creative image. Look for pictures and you will find them.

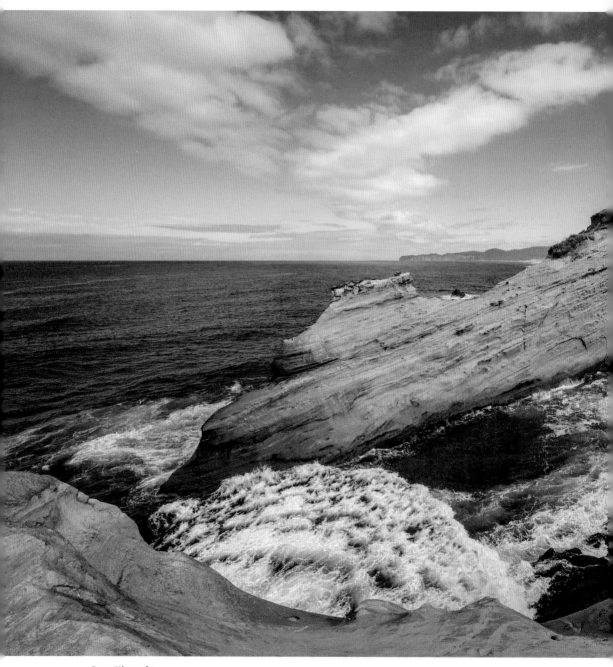

Cape Kiwanda

Cape Kiwanda

A stop at Pacific City is a must for photo road trippers on the Oregon Coast. This small area is packed with wonderful image-making potential. For a dramatic capture, hike up the sand dunes to overlook the mighty Pacific Ocean. This hike might appear easy, but it will get your heart pumping. Stroll the beach to find people fishing on the rock ledges and surfers riding the incoming waves.

In Cape Kiwanda, watch out for the local dory boats—they launch from the beach and return in a fast-action beach grounding. And glance out to sea—you're not seeing double; it's Pacific City's own Haystack Rock, which adds interest to your seascape photos.

If you stop at Cape Kiwanda en route to Newport, plan your visit around lunchtime, as there are plenty of places to eat, including an oceanfront brewery and an off-the-main-street treasure. We've listed our favorites in the "Cannon Beach Stay and Eat" section.

Cape Kiwanda State Natural Area

Pacific City, OR 97135

Photo Tips

Shoot it both ways: To get a shot like you see in the opening of this section, you'll need to climb the sand dune on right side of the beach. Pack your wide-angle zoom to capture the wide—and awesome—view. The view and photo opportunities from the beach are also cool. Try to time your shot so that the waves are caressing the rocks.

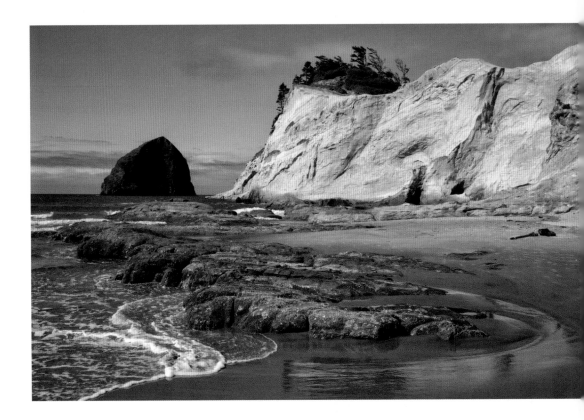

Don't forget verticals: In landscape and seascape photography, it's easy to forget to take vertical pictures. Sometimes a vertical picture can have more impact than a horizontal picture, as illustrated on the following page.

This picture was taken on the right side of beach, where you will find a few small caves and walk-throughs. Be *very* careful while exploring these areas. Watch out for sneaker waves. And as usual, wear your waterproof boots.

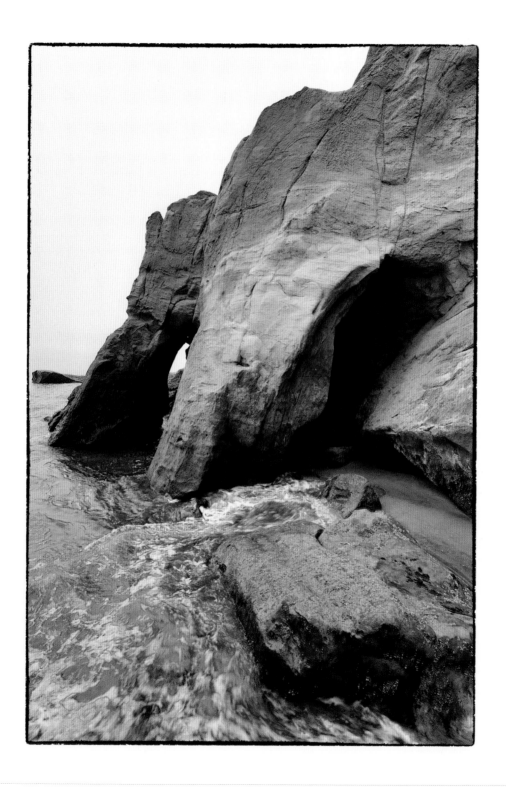

Cannon Beach Stay and Eat

LODGING

Hallmark Resort Hotel and Spa

1400 S. Hemlock St.
Cannon Beach, OR 97110
The perfect location will cost you. It's worth it. Nice rooms and friendly service.

RESTAURANTS

Sleepy Monk Coffee Roasters

1235 S. Hemlock St.
Cannon Beach, OR 97110
Lines form early. Start your day with smooth organic brew and fresh-baked treats.

Lazy Susan Café

126 N. Hemlock St.
Cannon Beach, OR 97110
Perfect spot for brunch or lunch. Cozy and cash only.

The Wayfarer Restaurant and Lounge

1190 Pacific Dr.
Cannon Beach, OR 97110
Fresh, yummy local seafood and good service. Just off the main drag, with a water view.

Pelican Brewing Company

1371 S. Hemlock St.
Cannon Beach, OR 97110
Lively spot. Local brews and gourmet pub fare. Open late.

Sampler at the Pelican Brewing Company

ON THE WAY (IN PACIFIC CITY)

Pelican Brewing Company

33180 Cape Kiwanda Dr.
Pacific City, OR 97135
Great location right on the beach. You can't miss it. Open for lunch or dinner.

The Grateful Bread Bakery and Restaurant

34805 Brooten Rd.
Pacific City, OR 97135
Tie-dyed shirts optional. Hearty fare for breakfast and lunch. A short drive from the beach.

Locally sourced fish tacos at The Grateful Bread

Devil's Punchbowl State Natural Area

Otter Rock Marine Reserve

Yaquina Head Light

PACIFIC OCEAN

101

Newport

Foulweather Trawl

Newport Harbor

Yaquina Bay Bridge

Oregon Coast Aquarium

20

101

Yaquina River

Seal Rock State Recreation Site

0 1 2 3
MILES

NEWPORT—
HOME BASE FOR THE NORTH-CENTRAL COAST

With a winning combination of photo opportunities—from stately lighthouses and art deco bridges to rocky cliffs and crashing waves—Newport is a photographic gem on Oregon's Central Coast. It is also a unique destination that combines a busy tourist trade with an active commercial fishing fleet. Best of all, Newport is authentic—with its foggy harbors, barking sea lions, and tide pools waiting for you to capture them.

The town itself is a bustling place, attracting photographers and non-photographers alike. You'll find lots of shops and restaurants to explore in the Historic Bayfront District. Stroll down SE Bay Boulevard, the main drag, to get a feel for the place and sample some fresh seafood. Then drive over the Yaquina Bay Bridge to visit two popular destinations, the Oregon Coast Aquarium and the Rogue Ales brewery.

There is plenty here to keep you busy—and full—for two days. We suggest staying in Newport, using it as a home base for your photo road trips north to Devil's Punchbowl and Yaquina Head Light and south to Seal Rock.

Newport Harbor

Newport's Bayfront area is very popular with tourists and photographers. The town's main street, SW Bay Boulevard, can get very crowded during the day, especially around lunchtime and dinnertime. It's a wonderful place to take photos of the docks and boats. If you plan to visit at mealtime, it's best to leave extra time for parking, because parking spaces are limited.

If you are looking to spend a few peaceful moments on the docks without crowds, it's best to go in the early morning or around dusk, as illustrated in the opening picture for this section.

Newport Harbor

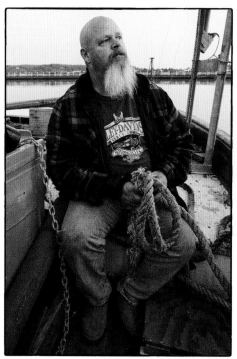
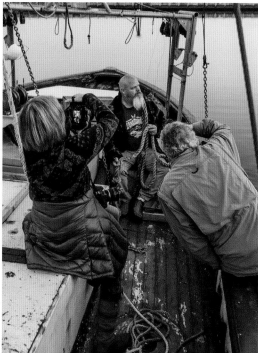

Newport Historic Bayfront
SE and SW Bay Boulevard
Newport, OR 97365

Photo Tips

Photograph the fishermen: You'll find plenty of fishermen to photograph in Newport, many of whom are more than happy to pose for a photo—if you ask nicely and promise to send a photo.

When composing your photograph, watch the background. Make sure it does not detract from the most important thing in the picture, the subject's face.

Try to see eye to eye and photograph eye to eye. At that angle, the person viewing the photograph will feel as though he or she is right there with you.

That's Rick on the right helping one of our workshop participants make a nice portrait.

Sea lions at Newport Harbor

Go for gesture: Sea lions seem to love Newport Harbor as much as we do. Pack a telephoto lens for close-up shots of these photogenic animals. Take a lot of pictures, and look for what's called gesture—an expression on the animal's face or a change in body language. The photo on the left shows a more active gesture than the photograph on the right.

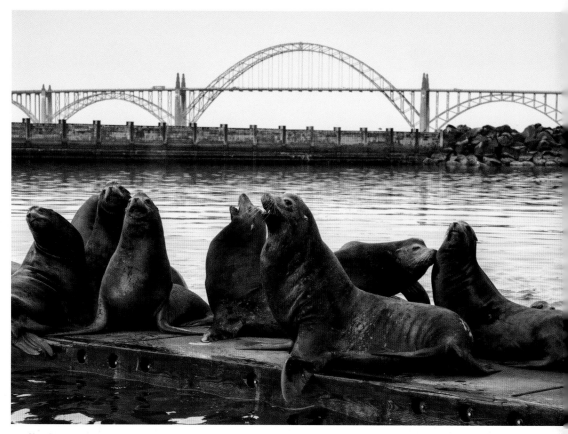

Sea lions at Newport Harbor

Watch the background: If you plan to walk on the floating piers, pack both a telephoto and a wide-angle zoom. If you are lucky, you may get a photograph of several sea lions. Include the Yaquina Bay Bridge in the background for a "sense of place" photograph.

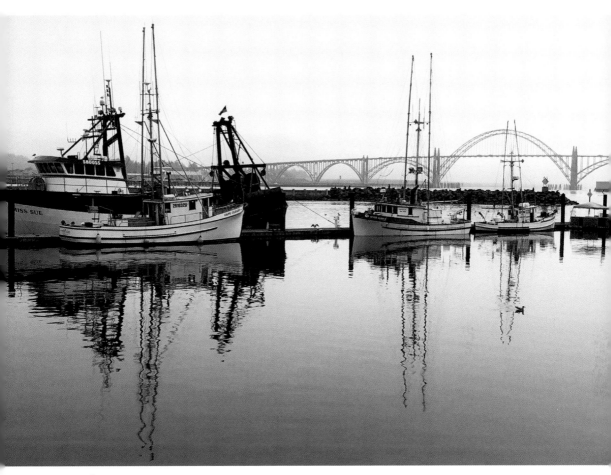

Newport Harbor

Try black-and-white: There is lots of color in Newport Harbor. But for perhaps a more creative touch, try converting a color file into a beautiful black-and-white image, which will change the mood and feeling of the scene.

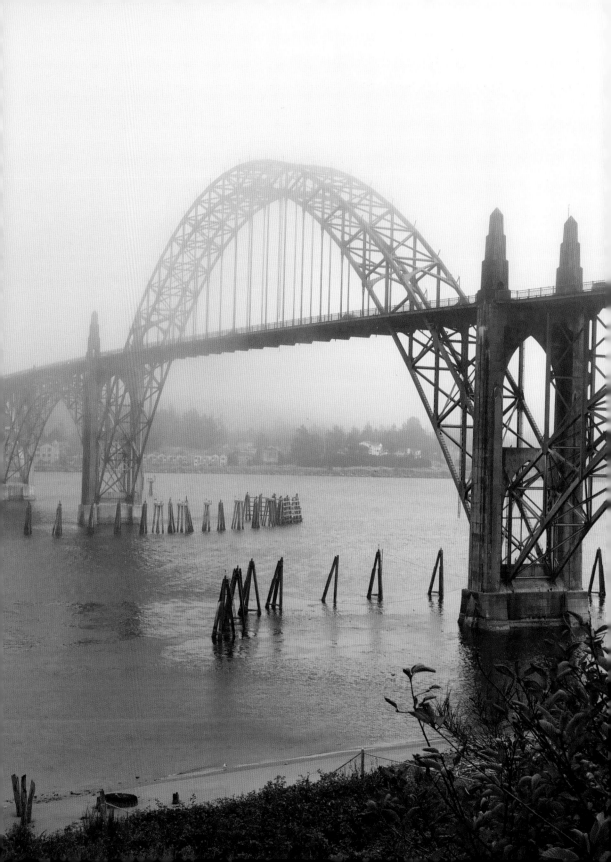

Yaquina Bay Bridge

The Yaquina Bay Bridge is a landmark in Newport. You will drive over the bridge, and over Yaquina Bay, as you travel from Newport's Historic Bayfront to the aquarium. It is a beautiful and iconic structure with an art deco design. It photographs well, especially in the evening light.

We found that the best place to photograph the bridge is from below, where you can get a picture that shows a wide view of the structure and that can include some passing ships if you are lucky.

To get to this viewpoint, park your car at the intersection of SW Naterlin Drive and Yaquina Bay State Park Road. There are a few parking spaces here just under the ramp to the bridge. Walk down SW Naterlin Drive past a few scenic overlook platforms until you see a sign on the fence for Yaquina Bay Beach Trail. Follow the dirt path until you see a safe place to walk down onto the shore. Once on the beach, you'll have a commanding view of the bridge. Wear your hiking boots, for sure.

Yaquina Bay Bridge
1950 SW Coast Hwy.
Newport, OR 97365

Opposite: Yaquina Bay Bridge

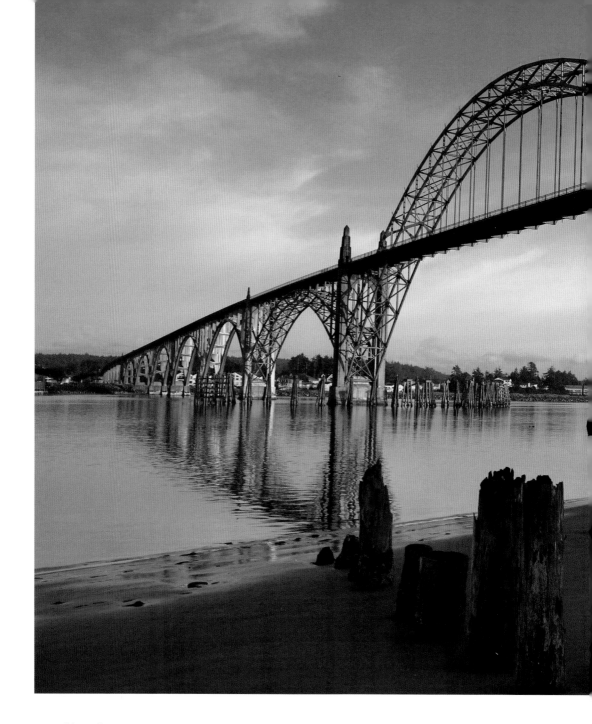

Photo Tips

Go wide: We like photographing the bridge in the late afternoon and at sunset. Bring your wide-angle lens and use the bridge's pilings to add a sense of depth to your photographs.

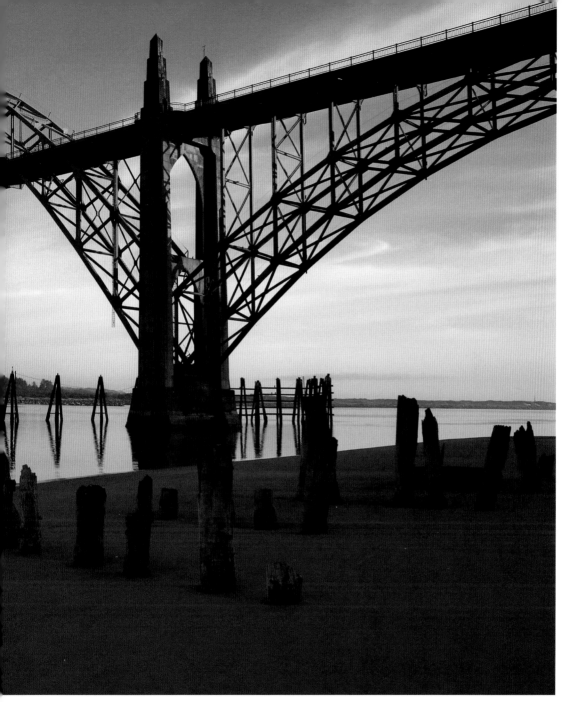

Yaquina Bay Bridge

Go up or down: Whether it's sunny or foggy out, the bridge is a great subject, from below (as shown on this page) and from a viewpoint on the street (as shown in the previous image). Try black-and-white, too. Also try a vertical shot.

Yaquina Head Light

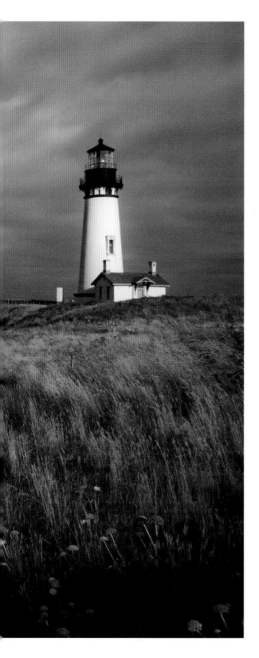

Yaquina Head Light

Perched on a steep, rocky, and often windy cliff, Yaquina Head Light is the tallest lighthouse (technically called a *light*) on the Oregon Coast. The ninety-three-foot-high structure is not the only attraction in the Yaquina Head Outstanding Natural Area—an area filled with marine life that extends a mile into the ocean.

This wonderful park is operated by the US Department of the Interior's Bureau of Land Management—so rangers are on-site to lead tours (along the shore and inside the lighthouse), answer your questions, and offer insights into the protected area. Of course, you can explore the area on your own when the park is open.

When planning your visit, keep in mind the park hours, because you don't want to be stuck at the gate waiting for the park to open, which is usually around 8:00 a.m. Call for the most up-to-date information, (541) 574-3100, or check the website for Friends of Yaquina Lighthouses, yaquinalights.org.

You'll have three main areas to explore and photograph during your visit: up top, around the lighthouse; down below, along the shore, which you reach by going down a paved path, down a wooden staircase, and finally onto the rocky beach; and from above, which you access by taking a trail to an overlook area.

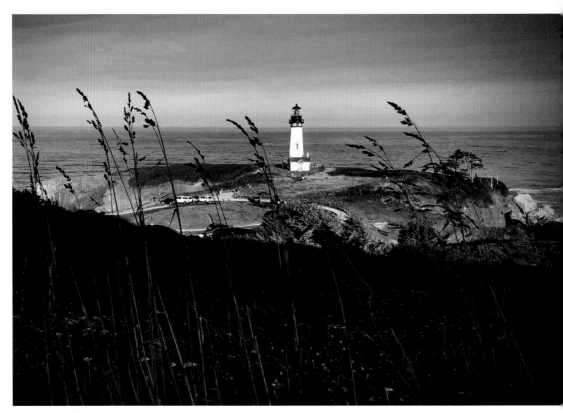
Yaquina Head Light

The lighthouse is an easy, short walk from the parking lot, which is about a three-minute drive on NW Lighthouse Drive off the Oregon Coast Highway (US 101). You can leisurely explore this area in your hiking boots. Before you go down to the shore, switch to your waterproof boots or waterproof overshoes, as you will be walking on slippery kelp and over algae-covered rocks.

If you have time, it's well worth it to go up top, around the lighthouse, for a cool wide-angle shot. Get down low to hide most of the parking lot. Don't forget to keep the horizon level when composing your image.

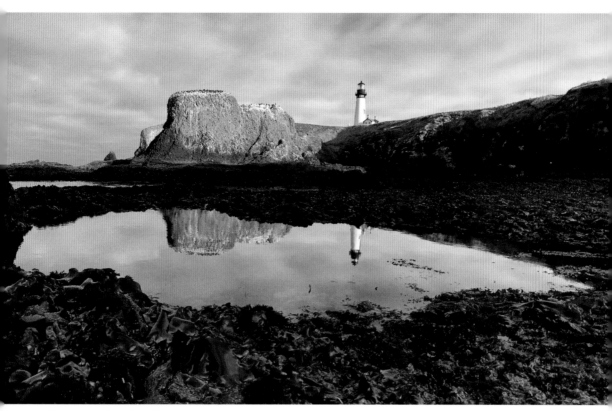
Yaquina Head Light at low tide

On calm days, you should get nice reflections from down below, along the shore. When composing a scene, look at the bottom of your viewfinder or LCD monitor and make sure the top of the lighthouse is not cut off.

Plan your visit during low tide if you want to explore the tide pools and get dramatic pictures of the lighthouse from below.

Yaquina Head Light
750 NW Lighthouse Dr.
Newport, OR 97365

Photo Tips

Take intimate landscape photos: You'll find many photo opportunities by the lighthouse and along the shore—as well as on the path between the two areas. Rick took the picture on the next page with his digital SLR and then enhanced it with the iPhone app Distressed FX. This is an intimate landscape image, a picture with a close-up foreground element and a distant background element.

Below is a before-and-after pair of Susan's iPhone images that illustrates how digital enhancements can, yes, enhance a scene. She used the iPhone app LensFlare to transform a flat color shot into a dramatic black-and-white shot with cool blue beams radiating from the light.

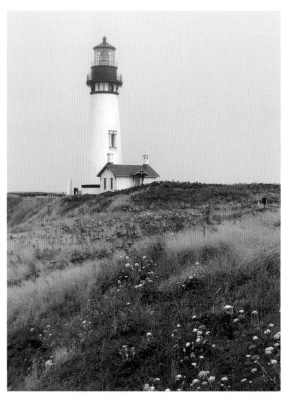 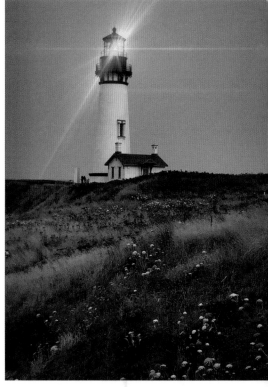

Yaquina Head Light

When you're using a smartphone for intimate landscape pictures, getting the scene in focus is easy because the very small image sensor offers good depth of field. When using an SLR or mirrorless camera, use a wide-angle lens and a small aperture—a combination of settings that will offer the greatest depth of field.

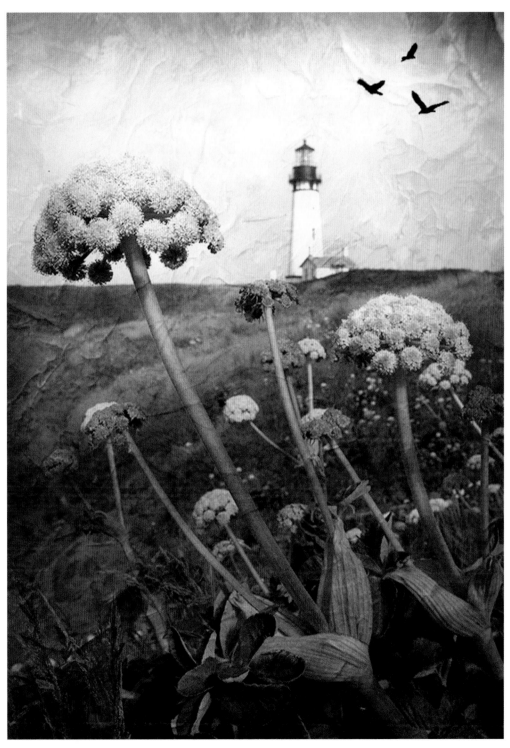

Yaquina Head Light

Zoom in for detail shots: For close-ups on the rocky shore, you can use a telephoto or a wide-angle lens. This photo was taken with a 17-40 mm lens set at 17 mm. Smartphones are also good for close-ups.

Look for pictures within pictures: Yes, the picture above is a cropped portion of this wide-angle view on the next page! Always look for a picture within a picture, and crop to focus on the interesting part of an image. Remember to shoot vertical images, too, because you may not know which one is best until you get home.

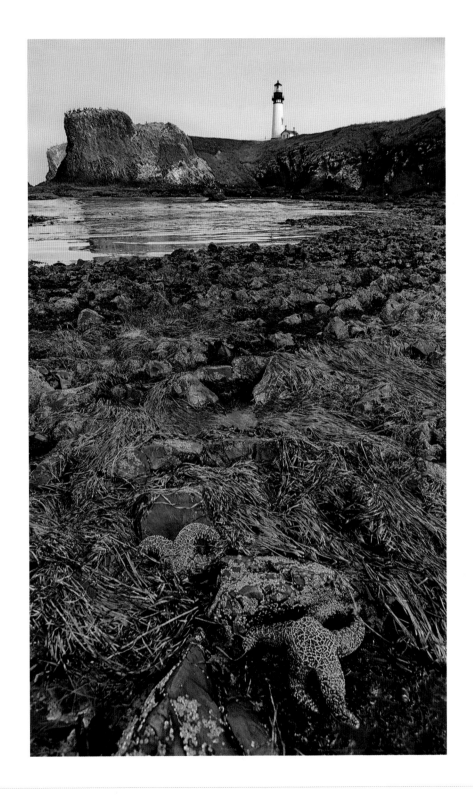

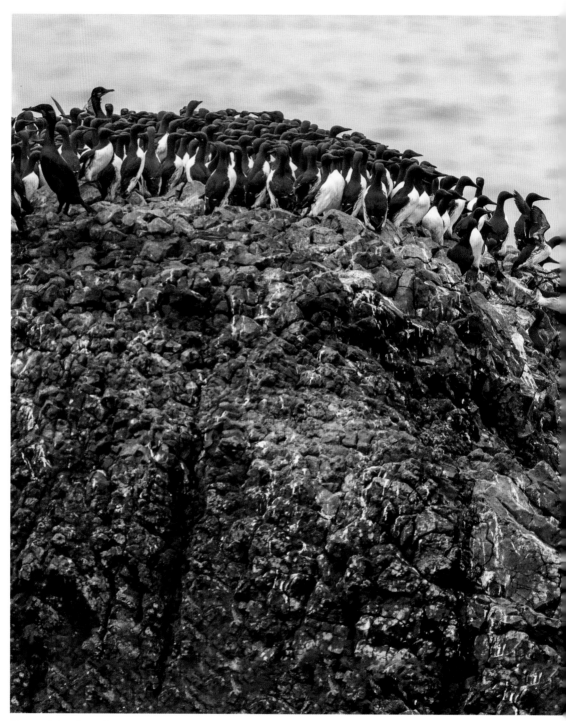

Photograph by Alex Morley

Capture birds in flight: If you are a birder, you will enjoy the variety of birdlife here, so pack your binoculars. If you are a serious bird photographer, and you have a 500 mm, 600 mm, or 700 mm lens, you can try to get shots of murres taking off from the rocks below the cliff the lighthouse is situated on.

This sign, on the way to the beach, says it all. As always, pay attention to signs, and stay safe.

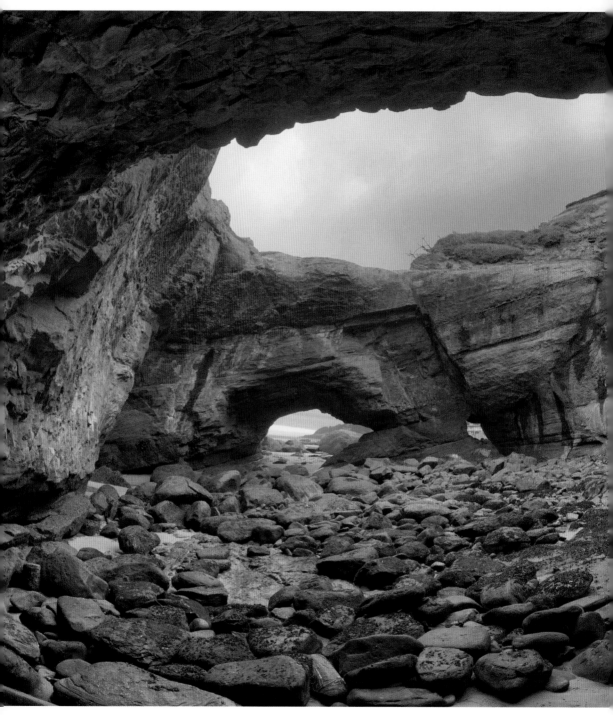

Devil's Punchbowl

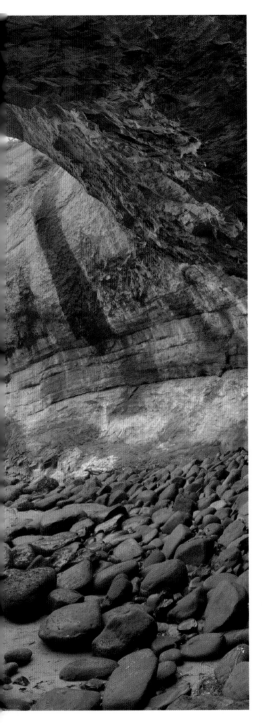

Devil's Punchbowl

Devil's Punchbowl State Natural Area offers Oregon Coast road trippers a unique visual experience and awesome photo opportunity: an inside-to-outside view of a collapsed cave, open sky, rocky shore, a sandy beach, and the Pacific Ocean. The HDR image that opens this section is the same image that is described in the "Rick's Quick Oregon Coast Photo Tips" section.

This striking natural formation is about an eight-mile drive north of Newport along the Oregon Coast Highway. Look for the sign for Otter Crest, Otter Rock, and Devil's Punchbowl. Once you leave the highway, drive down the road for about a quarter mile to the parking lot on the right side. Park at the far end of the parking lot. The trail to the cave area is not marked. Walk past the end of the parking lot and look for a sign to the beach. Follow the path until you see a trail on the left that leads to the beach.

Be sure to put on your waterproof boots, and then venture down the sandy and rocky—and sometimes steep—path to the beautiful beach. Once on the beach, walk to the left.

We know we have said it before, but check the tides and plan your visit if you'd like to venture inside the collapsed cave. If the tide is high, you won't be able to walk in. If you go in at low tide and spend too much time inside, it may be difficult or impossible to get out. Be alert to the danger of being trapped by an incoming tide. We plan our visits at low tide and usually spend less than an hour inside the cave area.

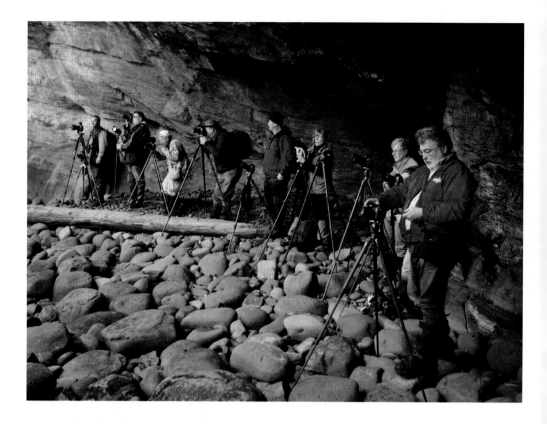

You'll need to be very careful as you journey to the center of the cave area. The algae-covered rocks are slippery and loose, so take your time.

Once inside the collapsed cave, you'll need to go to the very back of the cave to get the widest view for your photograph. Here you see some of our photo workshop students making pictures with their backs almost touching the cave wall. Conditions inside the cave area are always changing; sand can drift in or be pulled out by heavy seas.

Don't want to go inside the cave area? That's okay. You can explore and photograph the rocky shore and numerous tide pools that are filled with sea life. Here, too, watch your step on the slippery rocks.

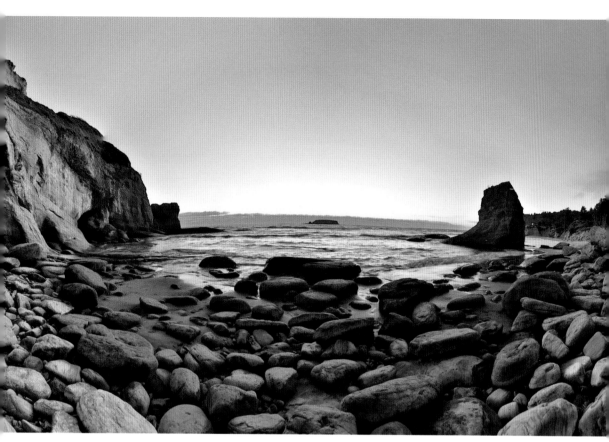

While you're walking on the shore, take both wide-angle and close-up photos, like this close-up of a small jellyfish that Susan found.

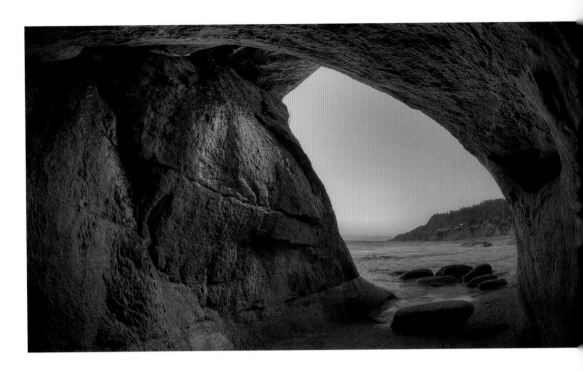

Devil's Punchbowl State Natural Area

Otter Rock, OR 97369

Photo Tips

Use HDR: Any time of day is a good time to photograph the inside of Devil's Punchbowl—if you use HDR photography to see inside and outside the cave. This sunrise HDR image shows the "window" inside the cave that faces the Pacific Ocean. The opening photograph for this section was taken in the early morning.

Go super-wide: For the widest, most dramatic photographs, you'll need an ultra wide-angle lens, such as a 14 mm or 15 mm lens. This photograph, as well as the opening photograph, was taken with a Canon 8-15 mm fish-eye lens set at 15 mm. The top photograph on page 129 was taken on the shore with a 14 mm lens.

Pack light: We recommend packing light if you want to photograph inside the cave, because walking on the rocks is tricky and slippery. Pack a camera and one or two lenses in your backpack and carry your tripod. Once in position, set up your gear and let the photo fun begin.

Keep dry: When photographing along the back wall of the cave, you'll need to keep your camera in a plastic camera bag to protect it from dripping water. You will also need a tripod if you want to do HDR photography.

Tell the story: Before you leave the area, we recommend viewing and photographing the main attraction from above. Exit the parking area and go right to the Devil's Punchbowl viewpoint. This scene will give you, and those you share your pictures with, an idea of the size of Devil's Punchbowl, and your picture will help tell the story of your adventure. This topside viewpoint also offers great vistas of the coastline north and south. On a clear day, you might even see Yaquina Head Light in the distance.

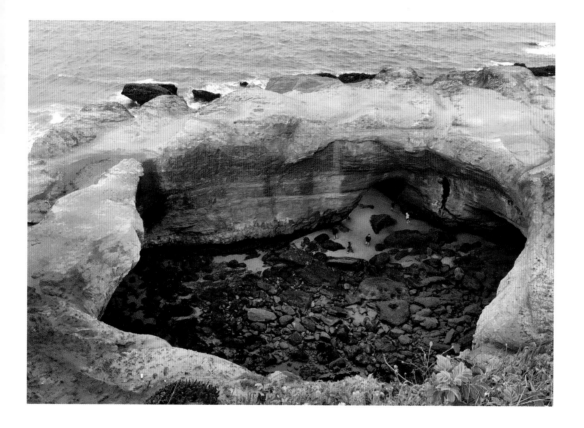

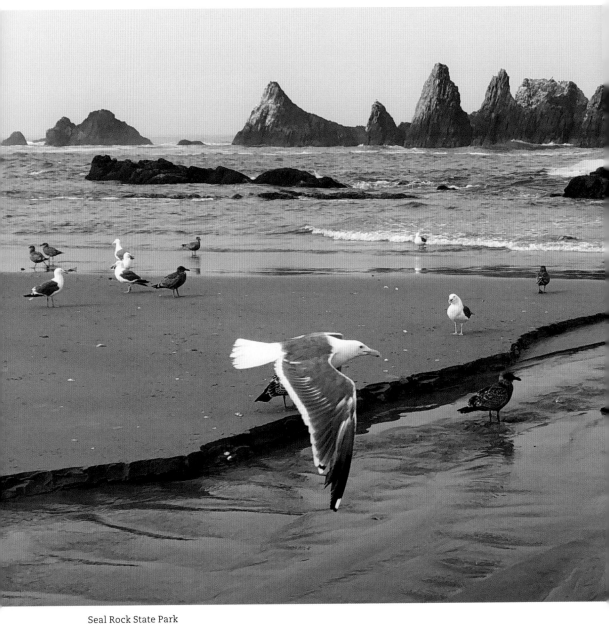

Seal Rock State Park

Seal Rock State Park

Seal Rock State Park, about a five-mile stretch along the shore, has something in common with most of the other locations we have described in this book: it's a wonderful place to explore and photograph at any time of the day. The opening photograph for this section was taken about two hours after sunrise, and the closing photograph was taken just after sunset.

You'll find lots of birds at Sea Rock. If you're lucky, a few might fly into your shot or pose on the top of one of the rocks offshore. Tide pools are exposed at low tide, when sea stars and anemones can be found. At high tide you might be treated to some crashing waves to add drama to the distant rocks.

From the parking lot, head toward the shore along a paved path. If you are there in the very late afternoon, look through the tall trees toward the ocean on your right. You might see a fairytale-like scene, like the one on the following page, which Susan took with an iPhone and then used LensFlare to enhance the starburst effect.

Before you head down to the shore, stop at the wooden lookout, enjoy the view, and take a shot. Then it's time to head down to the beach along the sandy and rocky path. Again, if you want to explore the tidal zone, you should wear waterproof boots.

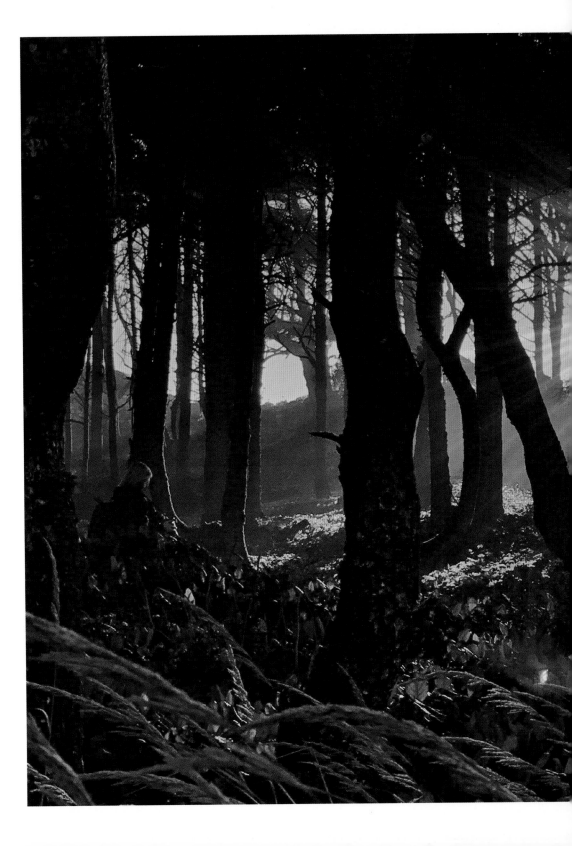

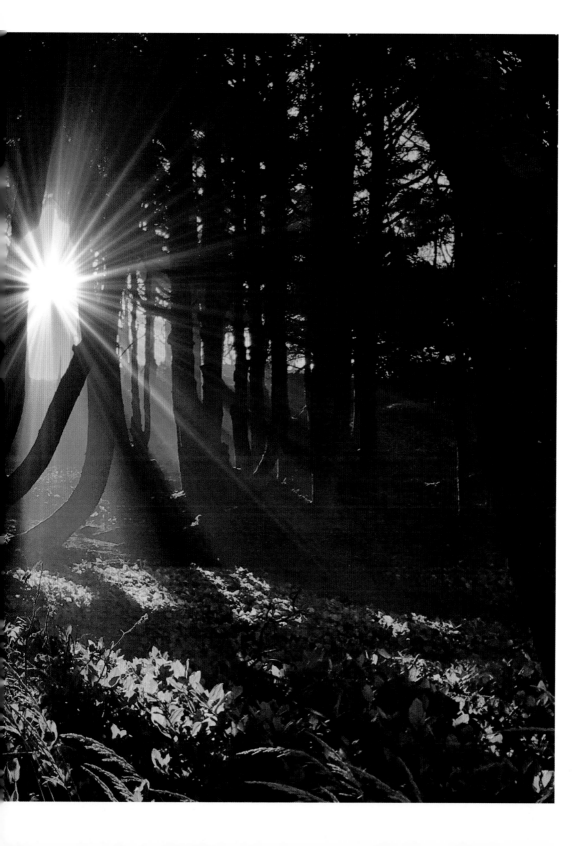

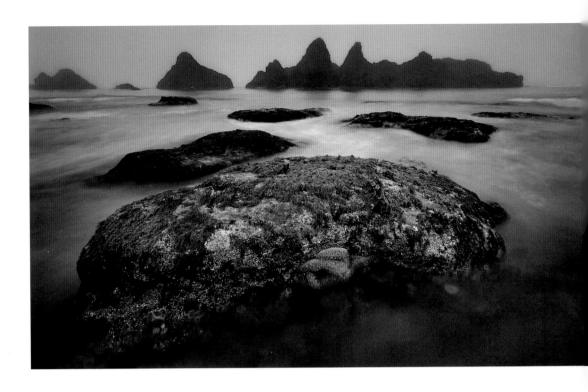

Seal Rock State Recreation Site
10032 NW Pacific Coast Hwy.
Seal Rock, OR 97376

Photo Tips

Don't dash off after sunset: Hang around for an hour or so and make photographs like this one during what is called the blue hour. Use your tripod, ND filter, and a long exposure to create a dreamy effect on the water.

Be on the lookout for birds: Take your wide-angle zoom for seascapes, but also take your telephoto zoom for bird photographs. Look for nice bird portraits as well as for photographs of birds on the move. When choosing your best photographs, choose the ones in which the birds have the best gestures.

Reflect: Compose your pictures with the reflections in the foreground. Also, reflect on the beauty of the Oregon Coast, and how lucky you are to be there!

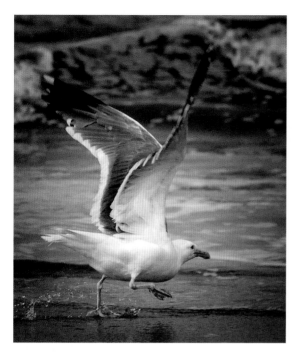

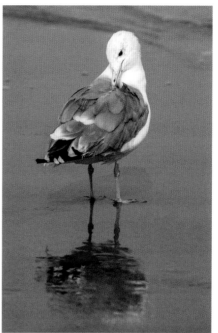

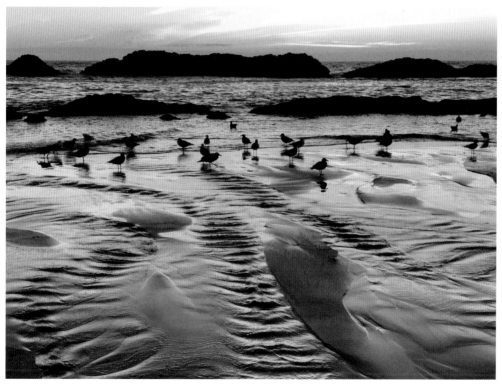

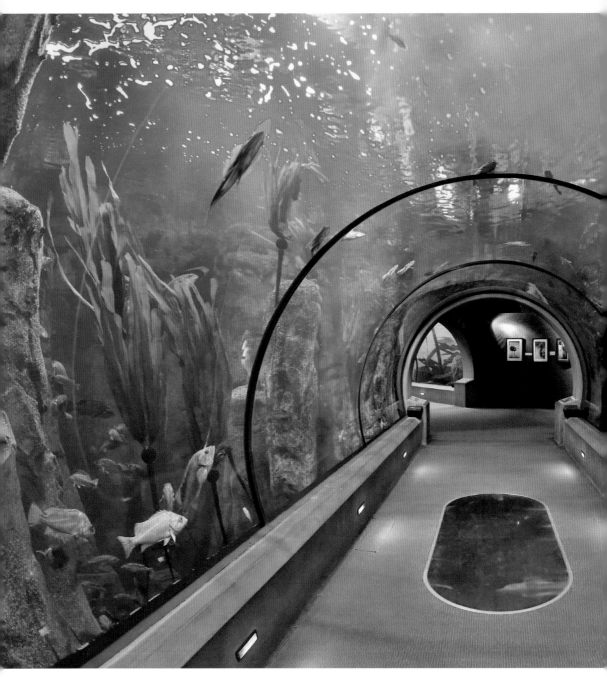

Oregon Coast Aquarium

Oregon Coast Aquarium

The Oregon Coast Aquarium is filled with wonders—and dozens of different species of fish, marine mammals, marine invertebrates, and birds. This expertly managed facility showcases the marine life of the area, including photogenic puffins, jellyfish, and sea otters.

For kids of all ages, the walk-though Passages of the Deep exhibit makes you feel like you're swimming with the fishes—including sharks. Photographers are welcome, but tripods are not.

You could spend a full day here visiting and photographing all the different exhibits; or, if you are like us, a two- or three-hour stay will be long enough to see the highlights and make some good pictures. The Oregon Coast Aquarium is easy to find. It is located off US 101 just south of the Yaquina Bay Bridge. Follow the signs.

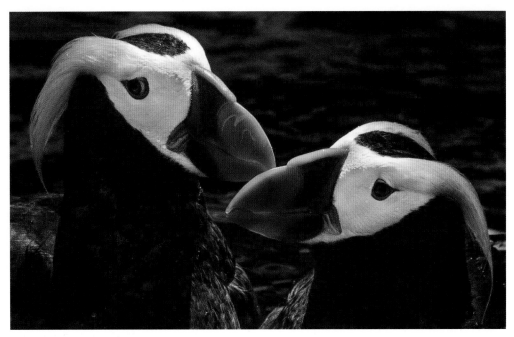
Puffins at the Oregon Coast Aquarium

In the wild, it's not easy to get close to puffins. Here at the aquarium it's simple. For our workshop participants, this exhibit is a highlight.

A colony of puffins entertain guests in two open-air exhibits, complete with shallow pools and natural-looking rocky backgrounds. Both pools are close to the path, which makes the puffins easy to observe. Getting a sharp shot is harder—these feathered subjects speed around their enclosure. We'll cover how to get a good shot in this section's Photo Tips.

Oregon Coast Aquarium
2820 SE Ferry Slip Rd.
Newport, OR 97365
(541) 867-3474
aquarium.org

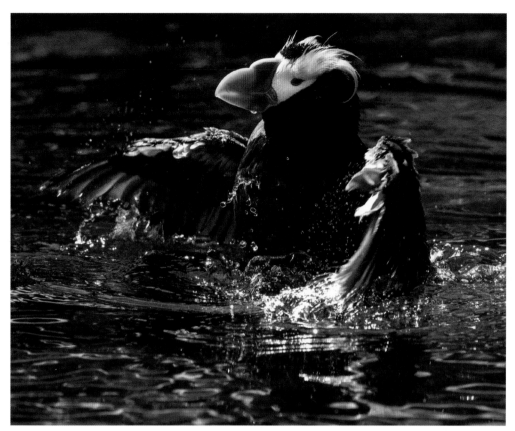

Puffin

Photo Tips

Picture the puffins: Puffins can move very, very fast. To stop the action of a fast-moving puffin, you'll need an SLR or a mirrorless camera. Use a shutter speed of about 1/2000 of a second.

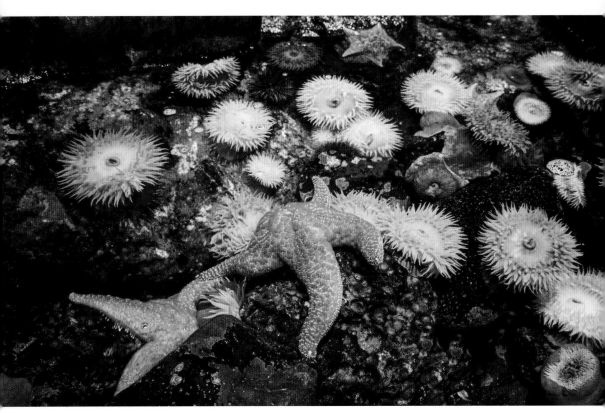

Tide pools at the Oregon Coast Aquarium

Try the tide pools: If you compose your picture carefully, so there is no distracting background and there are no reflections from overhead lights, your inside tide pool pictures can look as if they were taken outside along the shore.

You'll need to compose very carefully and move around to achieve those goals, but as illustrated by this photograph, it's possible—and good fun.

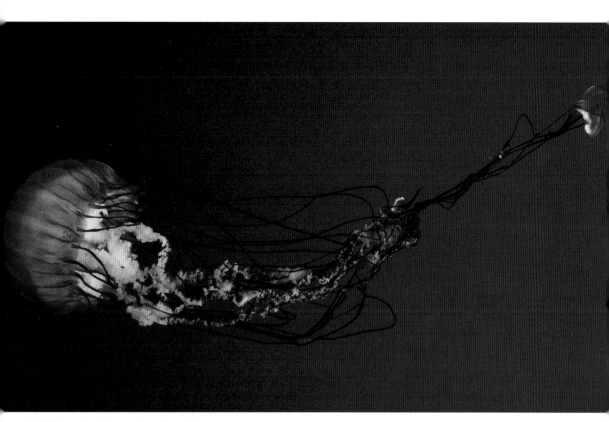

Jellyfish at the Oregon Coast Aquarium

Get gellin' with the jellyfish: You won't want to miss the jellyfish exhibits. And you won't want to miss getting a good photograph of these alien-looking animals.

Dealing with reflections is your biggest challenge here. To reduce them, you have two options: 1) shoot close with a wide-angle lens, or 2) use a telephoto lens and move around so that you can't see any reflections from the other tanks in the area.

Foulweather Trawl

One man's trash is another man's treasure—or a treasured photograph. On the Oregon Coast, Foulweather Trawl is a wonderful place to go on a treasure hunt and find photo treasures.

The close-up, abstract photograph below was taken on an old, rusting shipping container. It's an example of making photographs and looking for photographs—not just taking photographs.

Here's a boring shot of the shipping container where Rick found his rust pattern. See—looking for photos works!

Here's another example of making creative pictures. The picture on left is a compositional mess. But look what happened when Susan cut the clutter and used creative composition.

Foulweather Trawl

(541) 574-6424

Photo Tips

Use your small eyes: Spend an hour or so here using what we call your small eyes, and you will leave with some fun and artistic images, such as these close-ups of colorful fishing lines.

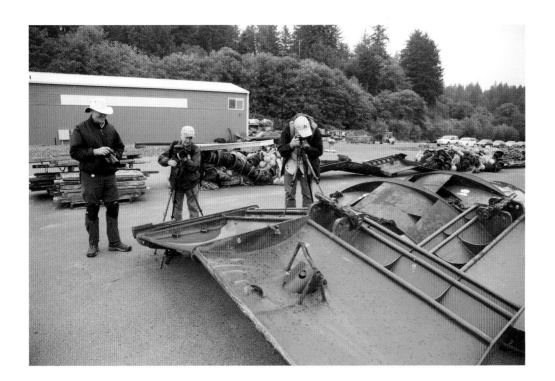

Get permission: Here are a few of my photo workshop participants making pictures at Foulweather Trawl during a workshop session. We had permission to photograph there. You, too, will need permission. Call the number listed above and ask for Sara.

Newport Stay and Eat

LODGING

Shilo Inns Newport Oceanfront
536 SW Elizabeth St.
Newport, OR 97365
(541) 265-7701
Budget friendly and well located.

Hallmark Resort Hotel Newport
744 SW Elizabeth St.
Newport, OR 97365
(855) 391-2484
A bit expensive, but rooms are nice.

RESTAURANTS

Fish tacos at Local Ocean Seafoods

Local Ocean Seafoods
213 SE Bay Blvd.
Newport, OR 97365
(541) 574-7959
Great seafood and fish tacos. Busy and
friendly.

Clearwater Restaurant
325 SW Bay Blvd.
Newport, OR 97365
(541) 272-5550
Good food and bar with indoor
and outdoor seating.

The view from Clearwater Restaurant

Georgie's Beachside Grill

744 SW Elizabeth St.

Newport, OR 97365

(541) 265-9800

Good seafood with a great ocean view, attached to Hallmark Inn.

Cafe Stephanie

411 NW Coast St.

Newport, OR 97365

(541) 265-8082

Good lunch place in the Nye Beach area.

The Deep End Cafe

740 W Olive St.

Newport, OR 97365

(541) 264-8672

Casual dining close to Shilo Inn.

Rogue Ales & Spirits Brewer's on the Bay

2320 SE Marine Science Dr.

Newport, OR 97365

(541) 819-0202

A fun place to visit that offers typical bar food and a great beer menu.

Dutch Bros. Coffee

822 SW Coast Hwy.

Newport, OR 97366

(541) 955-4700

A drive-through chain with great coffee and friendly service.

FLORENCE AND YACHATS—
HOME BASE FOR THE
SOUTH-CENTRAL COAST

Dramatic coastline favorites, including the most photographed lighthouse on the Oregon Coast, are easy drives from the seaside town of Florence. This is one of Oregon's most popular spots for traditional beach vacations; it includes long stretches of white sandy beach and mountain-like sand dunes. This area is favored by photographers seeking images of crashing waves, colorful tide pools, and a lighthouse that looks good—and photographs well—from many angles.

A good place to start exploring is in the Cape Perpetua Scenic Area. You can spend a whole day here. There's a wonderful overlook with a wide view of the coast from above the Visitor Center. You'll also find thrilling water and wave sights at three spots not far from each other right on the coast: the Devil's Churn, the Spouting Horn, and Thor's Well.

Some of the photo locations in this section of the central coast get crowded, like Heceta Head Light, while others are off the main circuit and you can have the place to yourself. Everything is pretty close together, so you can travel between locations to avoid the crowds and follow the best light.

Our home base when photographing in the area is the town of Florence. It has a good mix of beaches, dunes, and a charming Old Town full of shops and restaurants. But if you want a smaller neighborhood with a 1960s vibe, you might like the little resort town of Yachats (pronounced ya-hots). It's not far from Florence and will also get you close to the best photo-shooting locations in the area. You choose!

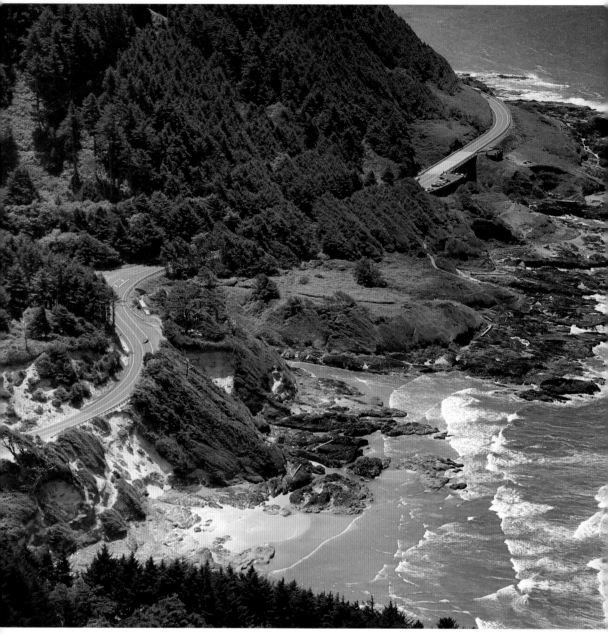

Cape Perpetua Overlook

Cape Perpetua Overlook

Get an awe-inspiring view of the coastline from the highest viewpoint accessible by car in the area. Drive up to the top of the Cape Perpetua headland and you'll have an eight-hundred-foot-high viewpoint. On a clear day you can see up to seventy miles of coastline. It looks good on both blue and gray days.

The trail starts just off the parking lot, and it is an easy hike. Just follow the signs to the rock shelter.

To find this location, look for the brown sign on US 101 for Cape Perpetua Day Use and Campground. It is about three miles south of Yachats and twenty-two miles north of Florence. Turn at the sign and take a left uphill when the road splits. Stay on the paved road up to the top to find the parking area and lookout.

Photo Tips

Pack a polarizer and use Dehaze: On a clear day you can easily see Thor's Well from the lookout point. For the sharpest shot, use a polarizing filter and/or the Dehaze tool in Photoshop or Lightroom.

Travel light: If you want to truly enjoy the hike, travel light. Take your camera and one lens in the 24-105 mm range.

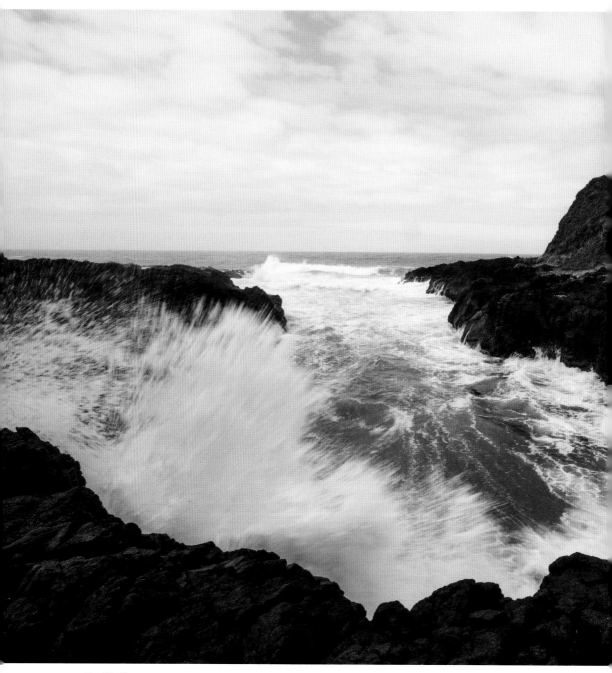

Devil's Churn

Devil's Churn

Three of the best photo opportunities—and awesome sights—in the Cape Perpetua area are close to one another on the coast. When you're driving south from Yachats, the first attraction you'll see is the Devil's Churn. This is a narrow and deep chasm probably formed by a collapsed lava tube. During high tide, incoming waves churn inside the inlet, making a big splash. You'll find a dedicated parking lot here, which can get full on busy days.

From the parking lot, where there are restrooms, follow the signs to the trail leading to the churn. You can get good photos right from the trailhead, but if you walk down onto the rocks below, you'll get even better photos. When the tide is high, be careful of waves and water spray.

Devil's Churn
US 101
Yachats, OR

Photo Tip

Keep it clean: Bring your lens-cleaning cloth to wipe salt spray off the front element of your lens . . . and off your glasses, if you wear them.

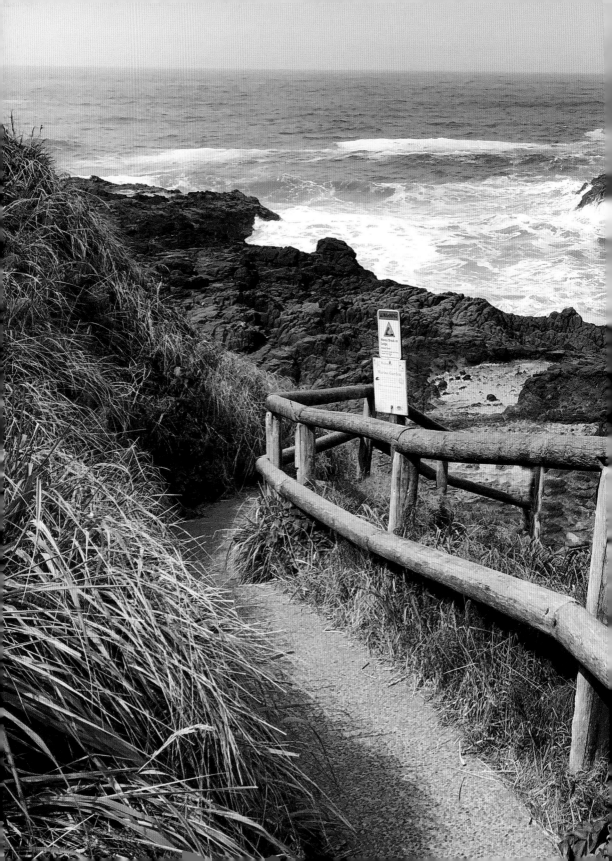

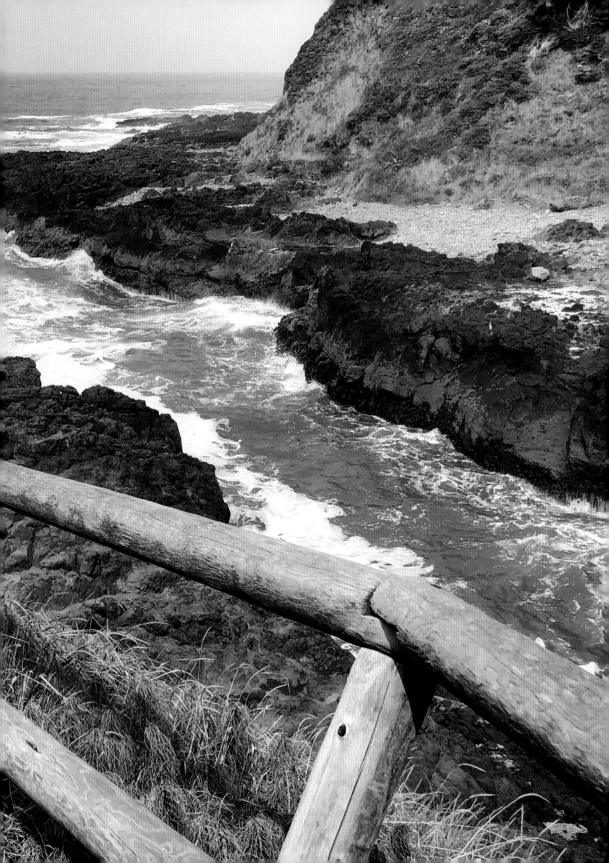

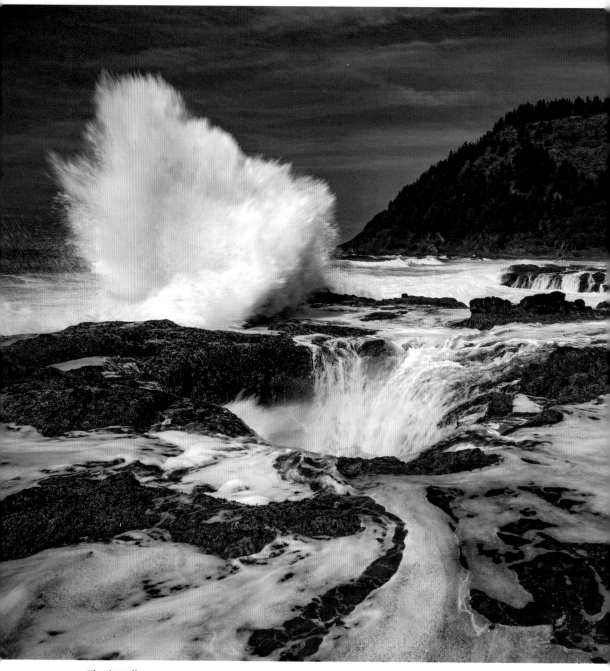

Thor's Well

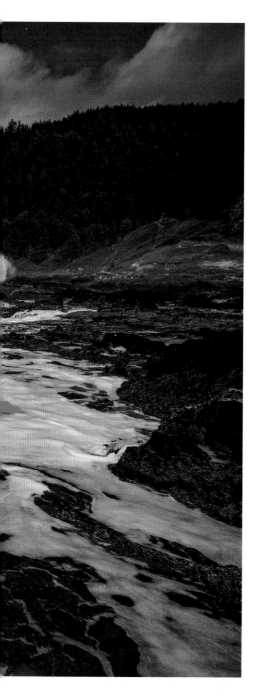

Thor's Well and the Spouting Horn

Thor's Well is one of the most dramatic natural sites on the Oregon Coast—one that any photographer will not want to miss, even if you have only an hour or so to spend there. This is the next must-see spot on the coast when driving south from the Devil's Churn.

The wave action here is unique: water entering a collapsed sea cave shoots up into the air and then recedes into the dark abyss. The natural formation is best seen and photographed at high tide, when waves sweep in and fall into the seemingly bottomless well, which is actually only about twenty feet deep. Again, wave action here can be dangerous. Take precautions and never prioritize a good photo over your safety.

Thor's Well shares the same rocky coastal location as another favorite attraction, the Spouting Horn. To find this blowhole, take the path toward Cook's Chasm and wait for a big incoming wave. If conditions are right, the water will shoot up like a giant saltwater fountain.

There is no entrance fee here; you can park on the side of US 101. The same parking area is used for Thor's Well and the Spouting Horn. After you park your car, walk down the stairs and then onto the sandy and rocky paths to the main attractions.

As opposed to the other pictures in this section, for the photo below Susan used a fast shutter speed to freeze the movement of the water. Try using both slow and fast shutter speeds, and choose the effect you like the best. Susan took this picture with her iPhone, which shows the awesome photo-capturing capability of a smartphone's camera.

Spouting Horn

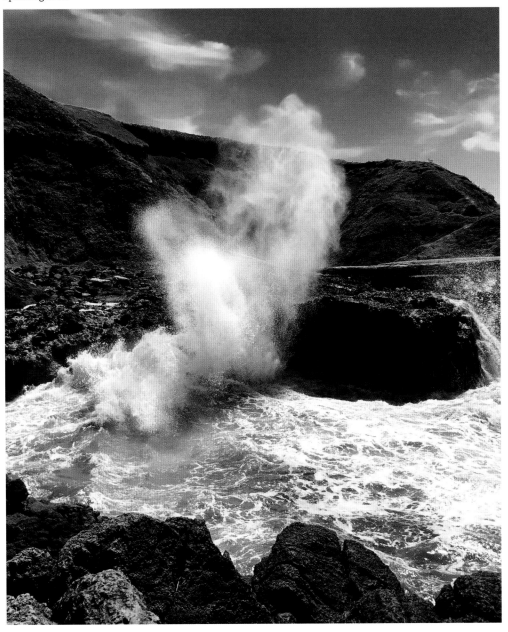

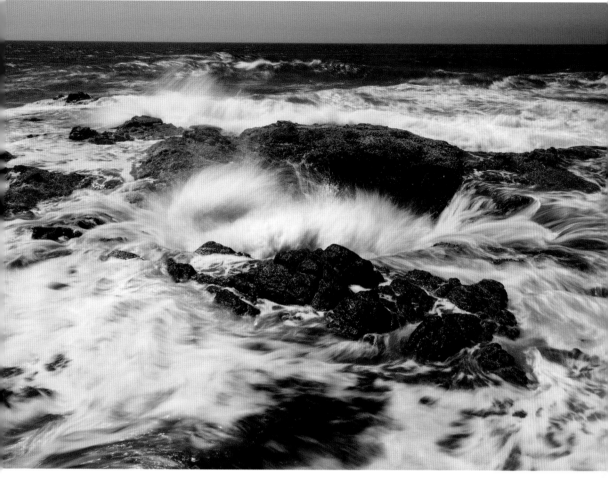

Thor's Well

Thor's Well

US 101
Yachats, OR

Photo Tips

Safety first: Our first photo tip is, again, to prioritize safety. Don't take chances and don't get too close.

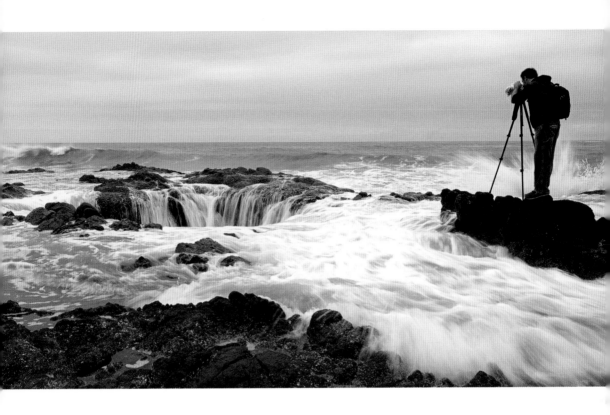

That's our friend Mike "Spike" Ince photographing Thor's Well. He was being cautious, watching for forming sneaker waves, and so were we. Notice that his tripod is set up fairly high. That's the best position to see down into the well, as illustrated in the next photograph.

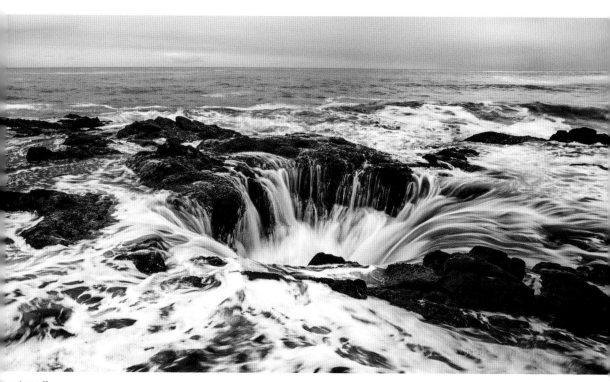

nor's Well

Slow it down: If you want to add a sense of motion to your still photograph, use a slow shutter speed, around 1/4 of a second. That means you'll need a tripod to steady your camera during the long exposure.

On bright, sunny days, you'll need an ND filter to reduce the amount of light entering your camera so you can use a slow shutter speed. You'll also need a plastic bag to protect your camera from the sea spray, and a lens-cleaning cloth to wipe water droplets and mist off your lens.

Or freeze the action: Use a fast shutter speed on your SLR or mirrorless camera—or shoot with your iPhone as Susan did for the photo on page 162—to freeze the movement of the water. For this type of photo, shoot at the peak of action.

Zoom in and out: Vary your zoom lens settings to tell the story of these dramatic natural formations.

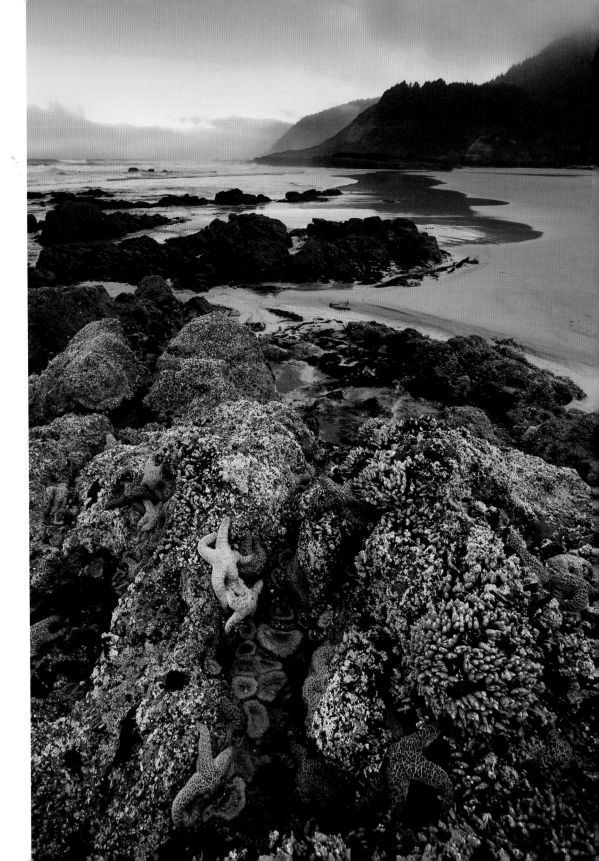

Strawberry Hill

Strawberry Hill, with its diversity of wildlife—seals, sea stars, shorebirds—combined with breathtaking views of the Pacific Ocean, is one of our favorite locations along the Oregon Coast. The area—with its steep decent and ascent to the beach, combined with climbs on jagged rocks—is also one of the more difficult areas to access. That being said, we usually spend two or three hours exploring this magical area . . . and have done so on each of our five Oregon Coast photo workshops.

As you drive along the Oregon Coast Highway (US 101), you'll need to keep your eyes peeled for the small sign that says Strawberry Hill. It's easy to miss. Strawberry Hill is one of four pull-offs in Neptune State Scenic Viewpoint.

Parking is fairly limited, so arrive early in the day. After parking your car, you may want to take a short break and enjoy the view while having a snack or a cup of coffee at one of several picnic tables. Once you are ready to go, put on your waterproof boots and carefully hike down the sandy and rocky path to the shore.

Take note of the path you're walking down, as there are several paths down and up to the parking lot. Also check the tides. If you arrive at low tide and leave at high tide, your path may be obscured.

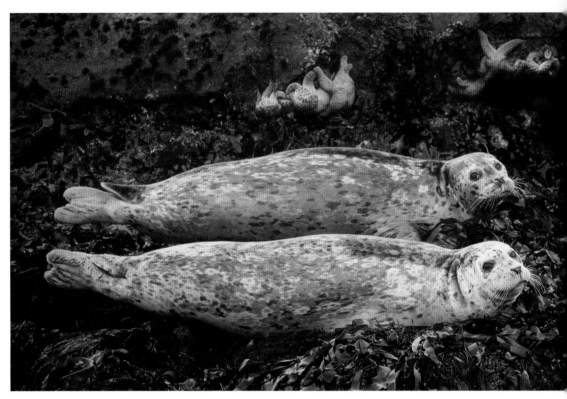
Seals at Strawberry Hill

Once on the beach, we go left to look for seals. Strawberry Hill is not a zoo, but we have seen seals on every visit. The seals use the rocks as a resting spot, and we have often seen adult and young seals taking a nap together.

You may need to climb over some slippery rocks to get a good view. It's not impossible that you could slip, so keep your camera (and iPhone, binoculars, wallet, etc.) in a backpack until you are ready to photograph. We know someone who slipped into a tide pool and all her gear was ruined. Be careful.

Strawberry Hill
US 101
Florence, OR

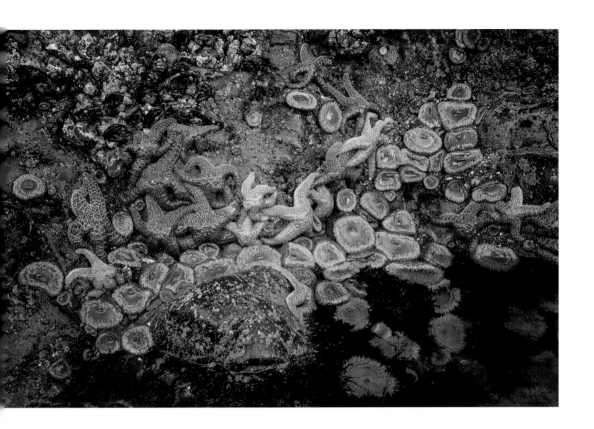

After photographing the seals, we move to the right and explore all the nooks and crannies of the rocky areas. This is where you'll find sea stars and sea anemones attached to the rocks, exposed at low tide.

Here are two of my friends, Steve Casey in the foreground and Gary Potts in the background, photographing at the same tide pool where I took the preceding photograph. Steve is wearing waders, which is a good idea for keeping your feet and legs dry if you want to explore deep tide pools. Gary is wearing knee-high rubber boots, which are recommended for shallow-water explorations.

Photo Tips

Tell a story: You'll need a variety of lenses to tell the story of Strawberry Hill.

The beautiful sunflower sea star on the following page was photographed with a 15 mm fish-eye lens.

The opening seascape picture for this section was taken with a 16-35 mm lens set at 16 mm, while the seals were photographed with a 100-400 mm zoom lens set at 400 mm. The tide pool scene was photographed with a 16-35 mm lens set at 35 mm.

For seascape pictures with great depth of field (everything in focus), use a wide-angle lens (16 mm or 17 mm), select a small aperture (f/11 or f/16), and set the focus one-third into the scene.

Sunflower sea star at Strwaberry Hill

For telephoto shots, keep an eye on your shutter speeds, as telephoto lenses exaggerate camera shake. If you don't have a lens with an image stabilization or vibration reduction feature, don't use a shutter speed slower than the focal length of the lens. For example, don't use a shutter speed slower than 1/200 of a second when using a 200 mm lens. With IS and VR lenses, you can use shutter speeds two, three, or more stops below that recommendation—depending on the lens's IS or VR capability.

Pack a tripod: In the photo of my friends Steve and Gary, both are using tripods to steady their cameras during long exposures. A tripod is needed when you're using a small aperture (which requires a slow shutter speed) for good depth of field.

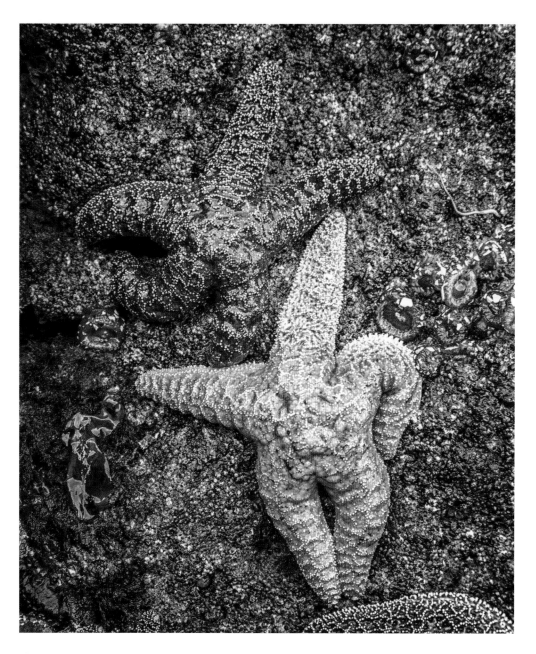

And speaking of tripods, our friend Alex Morley has a good suggestion: shower with your tripod. Sand and seawater are not a tripod's friend. After photographing in the surf, it's time to give your tripod a shower to keep it clean and working properly.

Look for and take fun shots: We call this one *Dancing with the Stars*.

Create a sense of depth: We love this picture by our friend John Van't Land. He shot from a low position, used a foreground element to add a sense of depth to the image, and achieved good depth of field by using a small aperture. Good job, John!

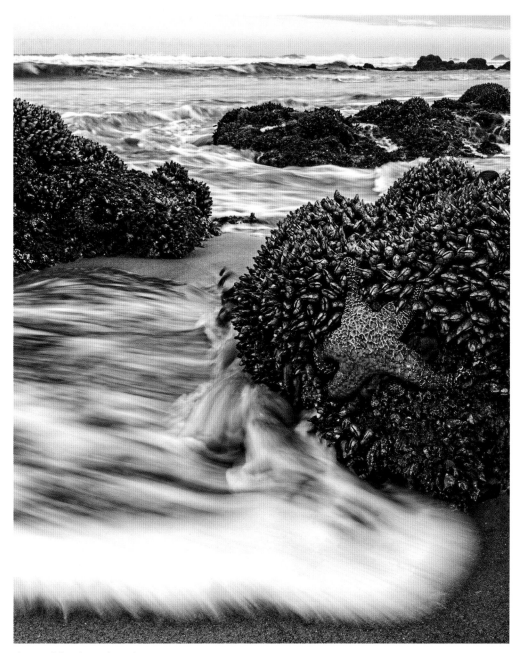

Photograph by John Van't Land

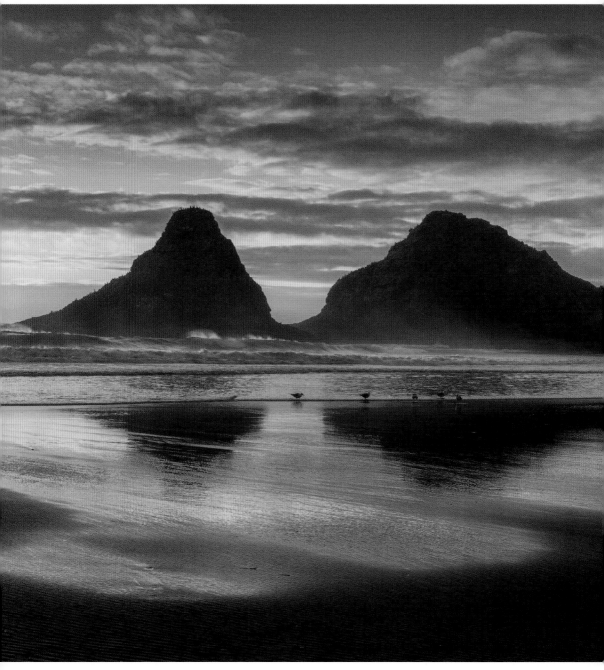

Heceta Head Light *Photograph by Steve Casey*

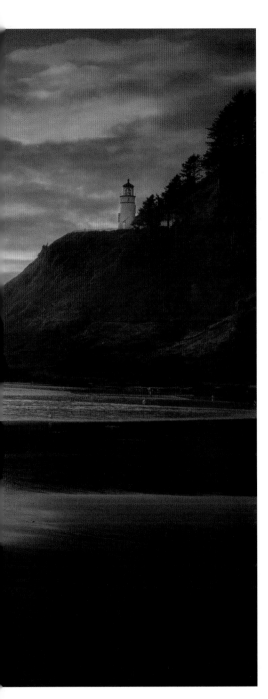

Heceta Head Light, Viewpoint, and Beach

Heceta (pronounced ha-see-ta) Head Light, which is perched 200 feet above the ocean on a cliff (Heceta Head), is one of the most photographed lighthouses on the Oregon Coast. It's located just off the Oregon Coast Highway about thirteen miles north of Florence and thirteen miles south of Yachats, and it is part of Heceta Head Lighthouse State Scenic Viewpoint. It's a state park, so you'll need your park pass.

We've taken, and seen, many photographs from this location, but the opening image for this section is our favorite. It was taken by our friend Steve Casey.

The park's proximity to Florence and Yachats, combined with the beautiful views of the lighthouse from the shore and views of the shore from the light, make this destination a must-see and must-photograph for Oregon Coast road trippers.

Heceta Head Light
US 101
Florence, OR

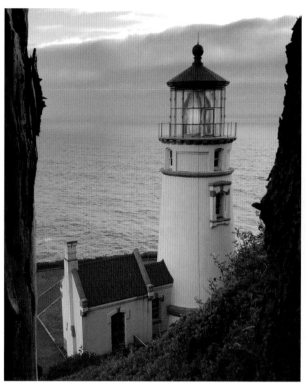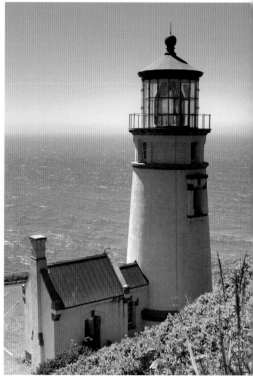

Heceta Head Light

It's a relatively easy fifteen- to twenty-minute hike up the path to the lighthouse for a breathtaking view of the Pacific Ocean with the lighthouse in the foreground. Whether it's sunny or foggy, you won't want to miss this view.

On your way up and down the path, stop and smell the roses. Enjoy the hike and the view, and take photographs along the way.

At low tide, the beach under Heceta Head Light is dotted with tide pools, which at sunset add to the beauty of the scene and make for dramatic photographs. If you plan to explore this area, waterproof boots are recommended.

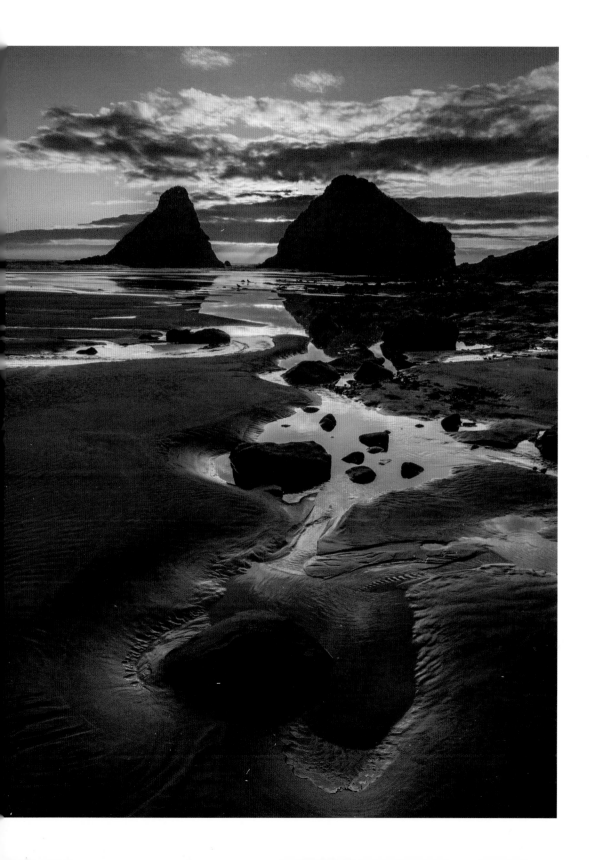

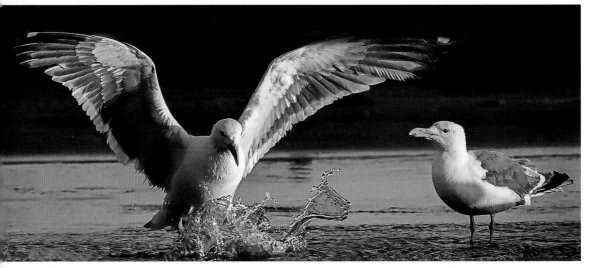

Photograph by Bob Lloyd

Along the beach you'll find seabirds looking for a snack. The birds are skittish, so bring your binoculars if you want close-up views. For full-frame shots like this one, pack your telephoto lens.

Want a romantic getaway, or just want to be on-site for first light? You can book a room in the Keeper's House, a bed-and-breakfast in the lighthouse that is open all year. For information, call (541) 547-3696.

Photo Tips

Follow the sun: We have found that the best time to photograph here is at sunset. It's not always sunny, but when the sun is shining, the views and photographs can be spectacular.

Pay attention to composition: When photographing up on Heceta Head, place the lighthouse in the foreground to create a sense of place in your photograph. Also keep an eye on the horizon line, making sure that it is level in your picture.

While you are photographing on the beach, use a foreground element to add a sense of depth to your photographs. Also, do what we call border patrol: run your eye around the edge of the image in your viewfinder, LCD monitor, or smartphone screen to make sure that what you want in the picture is included, and what you don't want is excluded.

Explore!: Be on the lookout for the unusual. Someone took a lot of time to make a balancing rock display at the entrance to one of the caves. Framing the shot from behind the rocks gives this photo a unique, new age feel.

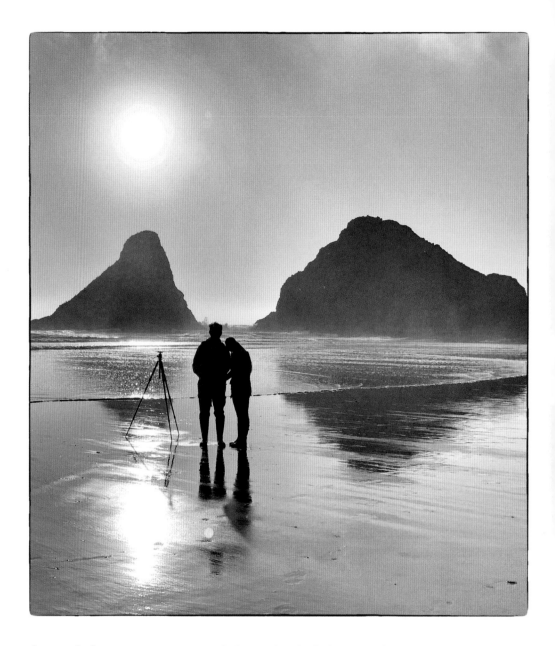

Capture the Instagram moment: Travel photos that include people in dramatic outdoor locations are popular on social media. Make an Instagram-worthy shot on the Oregon Coast by including your travel buddies. This silhouette of our friends Mike and Alex makes the beach location come alive.

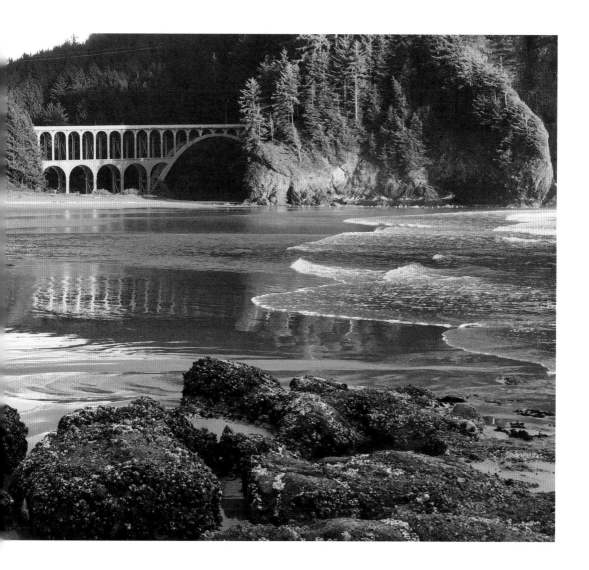

Always look back: The Heceta Head Light is a commanding presence, but there are other photo subjects to explore. After photographing the lighthouse, caves, and waves, take a look back toward the highway. The rocky shore and highway bridge can look great in the golden light, especially if you capture their reflections in the wet sand.

Think like a painter. Painting is additive, meaning that a painter adds elements to a canvas. Photography is subtractive. The photographer needs to subtract elements from a scene for a creative composition. Put another way: cut the clutter.

And speaking of paintings, photo-painting apps, when used correctly and creatively, can turn seascape photos into beautiful painting-like images. On the following page, Rick used Topaz Impression to transform one of his sunset photos into a more artistic image.

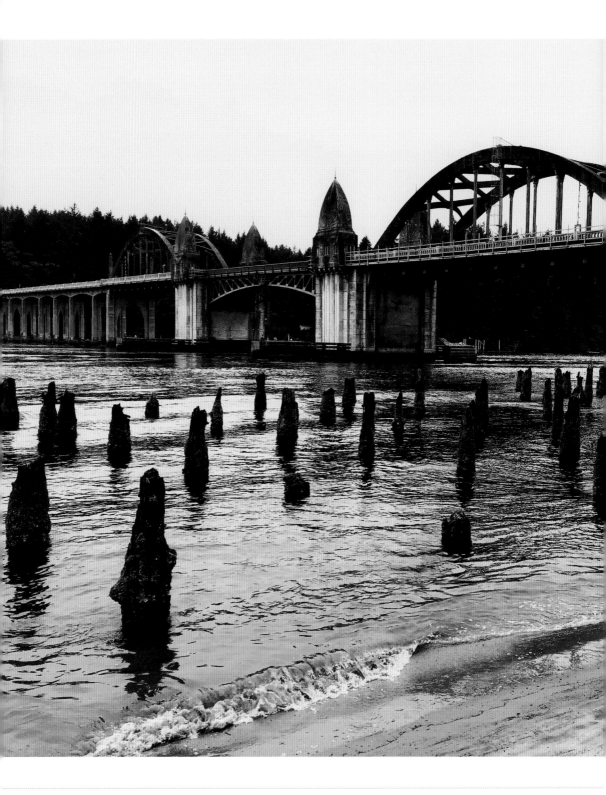

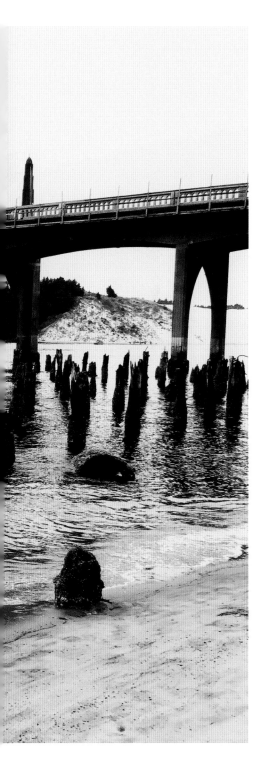

Old Town Florence

Photographers will enjoy the picturesque quality of Old Town Florence. You'll find lots of image-making potential in this waterfront location, as well as many restaurants. We recommend that you bring your camera to dinner so you can photograph the colorful shops, murals, and harbor attractions.

The Siuslaw River Bridge is a landmark of Old Town Florence. It has art deco styling and is reminiscent of the Yaquina Bay Bridge. That's because both structures were designed by the same architect, Conde B. McCullough.

Old Town Florence
Bay Street
Florence, OR 97439

Photo Tip

Use a foreground element: There is a good view of the river and bridge at the far end of Bay Street. Walk behind the Waterfront Depot Restaurant to gain access to the river's edge and use the old pilings as a foreground element.

Old Town Florence

Florence and Yachats Stay and Eat

LODGING IN FLORENCE

Driftwood Shores Resort

88416 1st Ave.

Florence, OR 97439

(541) 997-8263

Great location right on the beach, with big rooms and a nice on-site restaurant.

RESTAURANTS IN FLORENCE

Bridgewater Fish House and Zebra Bar

1297 Bay St.

Florence, OR 97439

(541) 997-1133

Lively bar and eatery featuring local seafood.

1285 Restobar

1285 Bay St.

Florence, OR 97439

(541) 902-8338

Casual dinner spot with Italian flair.

Waterfront Depot Restaurant

1252 Bay St.

Florence, OR 97439

(541) 902-9100

Popular dinner place overlooking Siuslaw River and its iconic bridge.

Casual and colorful dining await in Old Town Florence

Surfside Restaurant at Driftwood Shores

88416 1st Ave.

Florence, OR 97439

(541) 997-8263

Old-school decor and menu. Good views and fresh local seafood.

Fred Meyer

4701 US 101

Florence, OR 97439

(541) 902-7300

Big chain store with a good selection of deli and takeout items, as well as Peet's coffee.

LODGING IN YACHATS

Adobe Resort

1555 US 101

Yachats, OR 97498

(541) 547-3141

Budget-friendly beachfront rooms, close to everything in town.

RESTAURANTS IN YACHATS

Green Salmon

220 US 101

Yachats, OR 97498

(541) 547-3077

Groovy, healthy, busy. A great stop for breakfast, lunch, or coffee.

Vegetarian delights at the Green Salmon in Yachats

Luna Sea Fish House

153 US 101

Yachats, OR 97498

(541) 547-4794

Local favorite for fish and chips. Seating is at picnic tables outside. Service is friendly.

Yachats Brewing & Farmstore

348 US 101

Yachats, OR 97498

(541) 547-3884

Cozy and casual brewery with inspired local food. Many non-fish items. Great beer menu.

BANDON—
HOME BASE FOR THE SOUTHERN COAST

Even the most experienced traveler will not be disappointed upon visiting Bandon. With stunning sea stacks rising up from the restless ocean, an iconic lighthouse, and a colorful Old Town, photographers count the town of Bandon and Bandon Beach as high points on their Oregon Coast photo road trip.

For us, Bandon marks the southern end of our recommended photographer's road trip. Yes, there is more of the coast to explore south of Bandon, but our itinerary features a road trip that you can complete in a week.

Bandon's feel marks a contrast with our starting point at Cannon Beach. Unlike the busy and crowded beach, Bandon is a quiet and restful town. That's welcome news for photographers. Plus, good food and lodging can be found in Bandon. This town is a destination for serious golfers and outdoor enthusiasts. On your stay, you will enjoy really good local seafood and coffee along with photographic wonders.

Old Town Bandon

Old Town Bandon

All roads lead to Old Town Bandon, or at least close to it. It's a small town, just ten square blocks, with picturesque storefronts and a welcoming vibe. You'll find yourself here to pick up coffee after an early shoot, or to grab some fish tacos before heading to the beach for sunset.

You'll enjoy the street art around town, too. Washed Ashore has installed a collection of giant sea life sculptures made entirely of marine trash collected on the beaches. The art is beautiful, and its message is powerful. Visit washedashore.org for more information.

There are lots of friendly faces in Old Town—including the cooks at Tony's Crab Shack, where you can even bring your own crabs for cookin'.

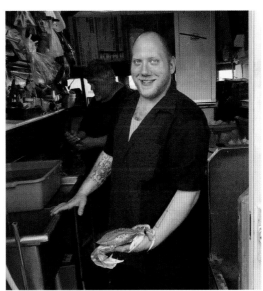

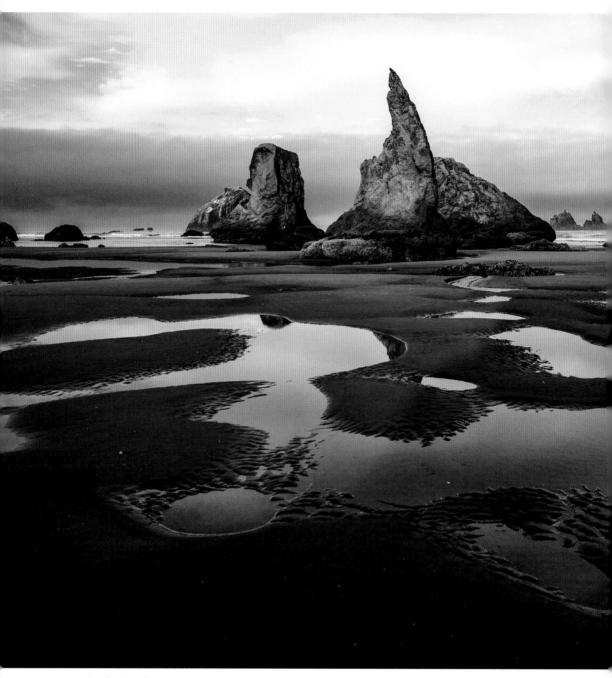

Bandon Beach

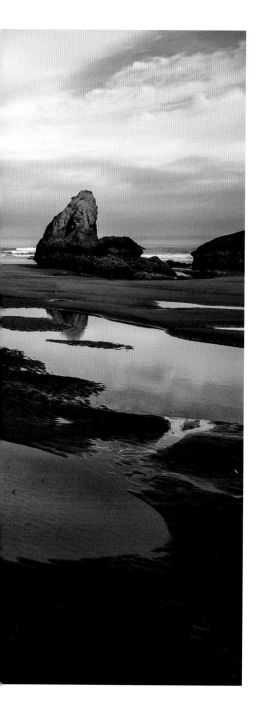

Bandon Beach

The beach at Bandon is open 24-7, year-round. The main attractions are the sea stacks that rise majestically out of the shoreline. The names of these Bandon Beach icons—like the Howling Dog, Wizard's Hat, and Face Rock—hint at their shapes, which are sure to visually inspire. Combine these formations, created by wave and wind erosion, with stunning skies, and you have the perfect location for a sunset walk or a sunset photo shoot . . . if the sun is shining.

We have seen breathtaking sunsets on the beach, but we have often encountered overcast days and even days when the fog was so thick it was hard to see all the sea stacks. Still, the experience of being on the beach, and witnessing the power of Mother Nature, is always awe-inspiring.

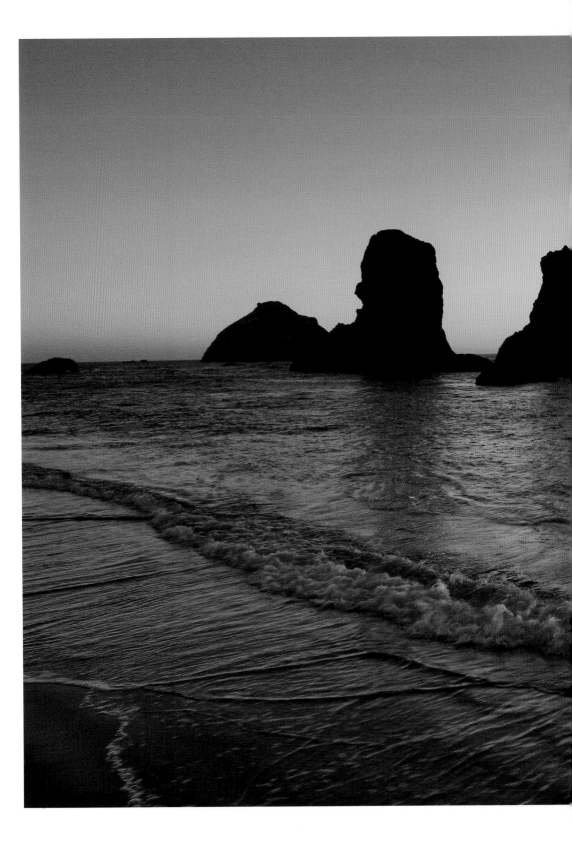

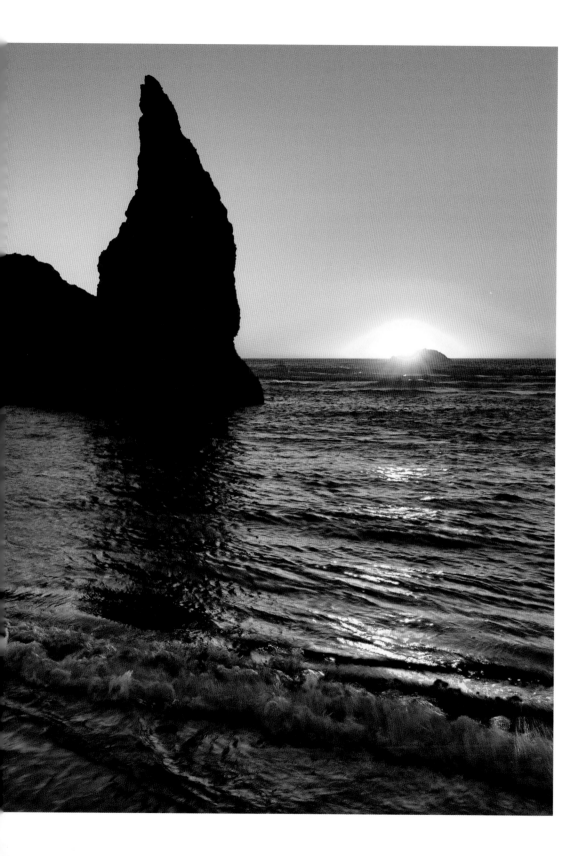

To be comfortable during a spring and summer beach visit, wear a rain jacket and rain hat—just in case. During the winter, a warmer jacket and gloves will keep you toasty. And don't forget your waterproof boots.

There is public access to the beach, with stairs and parking, at the Face Rock State Scenic Viewpoint. We like to stay at Sunset Oceanfront Lodging so we don't have to drive and can just walk down the hotel steps (more than 140) to the beach. It is a steep climb. If you stay in one of the oceanfront units, you can take sunrise and sunset images from your room, which can be a nice perk in challenging weather.

As always when exploring areas on the Oregon Coast, we check the tide charts and plan our visit at low tide, which at Bandon is the time to photograph the sea stacks with the opportunity for beautiful reflections in the foreground.

The photograph below, taken by Alex Morley from the cliff above Bandon Beach, captures a seagull in flight and a view of the beach as high tide moves in. As you can see, high tide is not the time to walk around the sea stacks.

Bandon Beach *Photograph by Alex Morley*

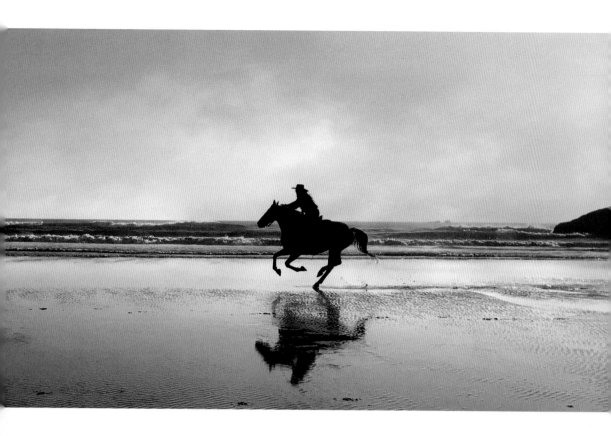

Like horseback riding? Like photographing horses? You can arrange a ride or a photo shoot through Bandon Beach Riding Stables. We enjoy scheduling a photo shoot of a horse running on the beach for our Oregon Coast photo workshops. The light is always different, and each session has provided wonderful photo opportunities for our workshop participants.

And now for something completely different. The photograph on the next page, taken by Susan Dimock at low tide on Bandon Beach in March 2018, shows the work of the interactive sand art master Denny Dyke, with detailing by Christine Moehring. This Bandon attraction began as a project of Denny's labyrinth ministry, called Sacred Journeys, and has become a magical, meditative walk enjoyed by locals and tourists of all ages. Walks begin in March and continue through the summer, typically ending the first week in October—on very low tide days only.

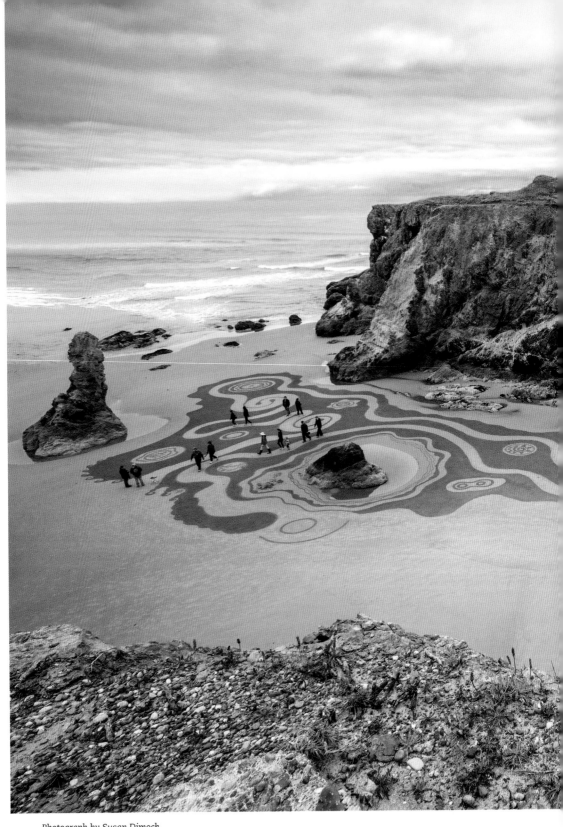

Photograph by Susan Dimock

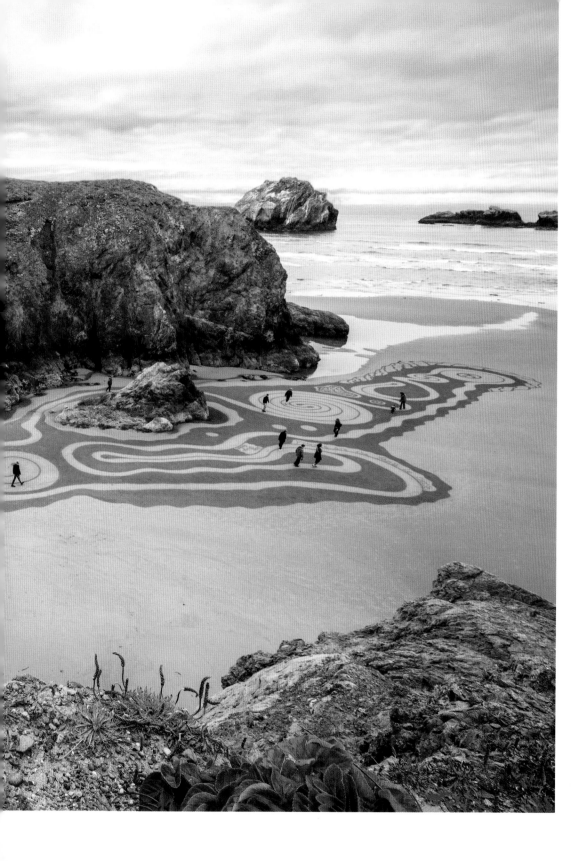

Face Rock State Scenic Viewpoint

Beach Loop Road
Bandon, OR 97411

Photo Tips

Careful with the sun: When photographing a sunset, use Live View and look at the scene on your camera's LCD monitor. If you look though the viewfinder at the bright sun, you could damage your eyes.

Try composing a sunset shot with the sun just peeking out from behind a rock. This will reduce the contrast range in a scene and help you get a good exposure.

Stay up late: Our friend Alex Morley took the picture on the following page of the Milky Way on Bandon Beach using a shutter speed of 1/25 of a second. If it's a clear night, you could get a shot like this!

Opposite
Milky Way over Bandon Beach
Photograph by Alex Morley

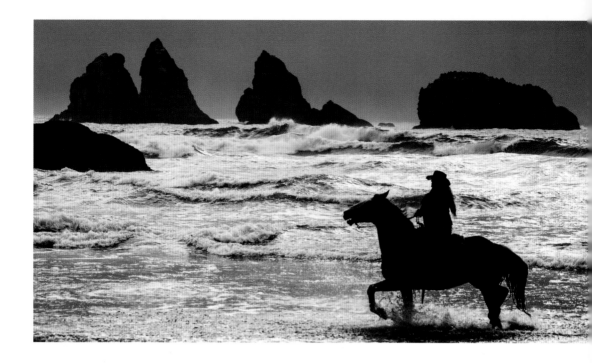

Capture the action: Photographing horses running on the beach is fun! Use a fast shutter speed, at least 1/500 of a second, to stop the action. For shots like this, use your telephoto zoom.

Set a goal: This photograph of a horse and rider dashing toward Face Rock is the result of careful planning. We directed the rider to ride from right to left so that she was moving toward Face Rock. We used a wide-angle zoom to capture a wide scene. In this and the following photograph, notice how the elements are separated. When it comes to composition, separation is key.

Take behind-the-scenes shots: Sure, it's fun to capture the action of a horse running on the beach, but don't forget to take behind-the-scenes shots of the fun (as you can see in the photo on the right)!

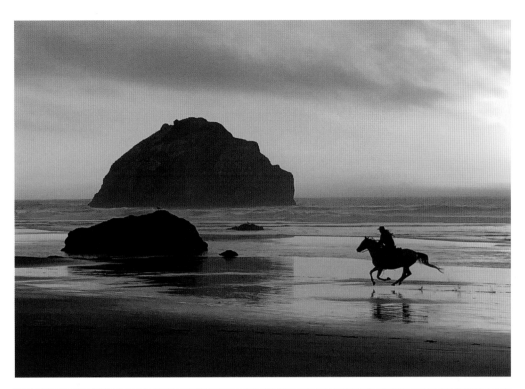

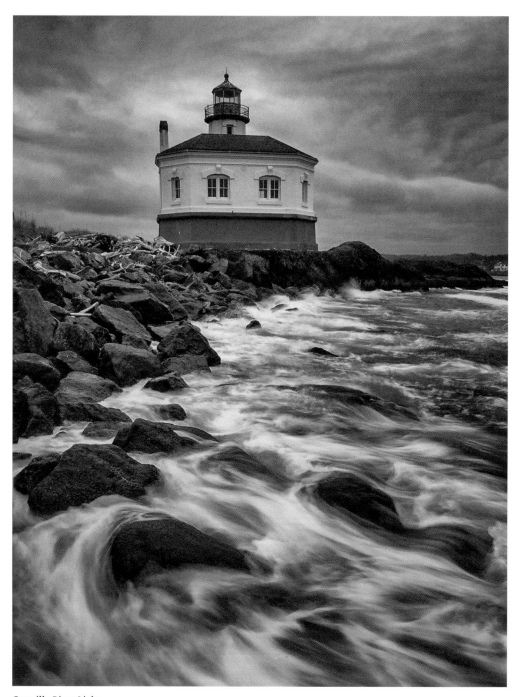

Coquille River Light

Coquille River Light

The Coquille lighthouse, originally named the Bandon Light, is a must-see when you are in Bandon. It's part of Bullards Beach State Park, and is accessed from Bullards Beach Road off the Oregon Coast Highway.

The lighthouse is located at the mouth of the Coquille River, and it can be seen and photographed from several viewpoints. Get up close to the lighthouse at the main visitor area; you can use rocks and tall grasses as foreground elements in a photo.

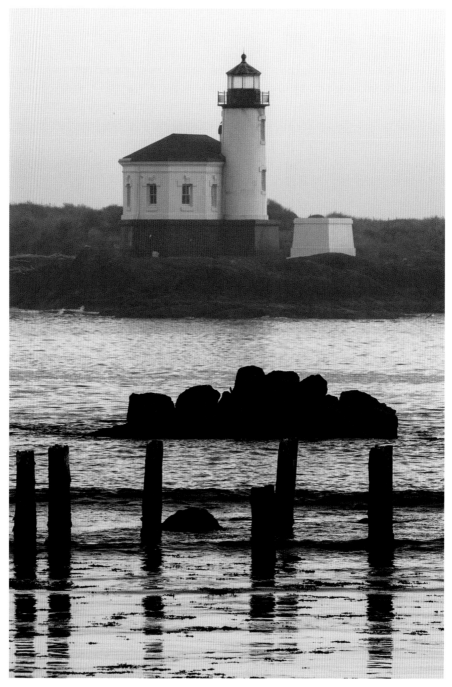

Coquille River Light

In the early-morning light, try shooting from the opposite side of the river along Jetty Road SW. Find a clearing overlooking the lighthouse as you drive toward Bandon South Jetty Park.

You can visit the outside area of the lighthouse all year round, but access to inside the building is limited, and the tower is no longer accessible. Best to call ahead if you want to see inside.

If you are careful and intrepid, you can climb down the rocks by the lighthouse for a cool view and a nice photograph. You will also find photo opportunities on paths that weave through the tall grasses on the surrounding sand dunes, and at a nearby pier.

Coquille River Lighthouse
56487 Bullards Beach Rd.
Bandon, OR 97411
(541) 347-2209

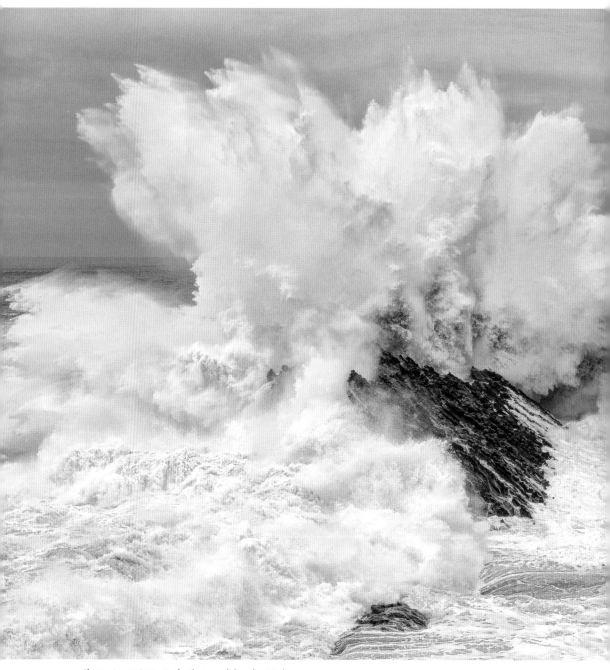

Shore Acres State Park *Photograph by Alex Morley*

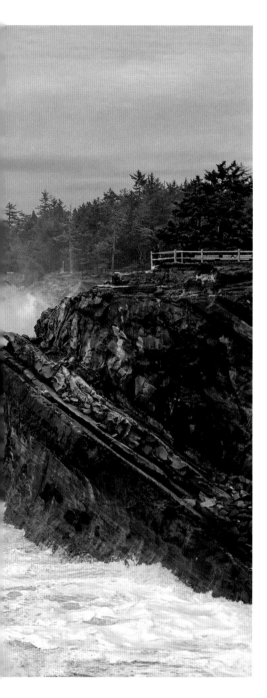

Shore Acres State Park

Shore Acres State Park is a photography treasure! It is not on the main highway—you need to drive on a twisting road to get there, but it is worth the effort. The park is located in the Coos Bay area, about twenty-five miles north of Bandon. A former estate property, Shore Acres is now a wonderland featuring a dramatic rocky shore, unique sandstone cliffs, and dazzling flower gardens. It's a place where you can spend hours exploring and photographing—and picnicking in the sun on wooden tables.

There is something very special about Shore Acres. It is said to be the best place for watching crashing waves in the winter, as illustrated by the opening picture for this section, taken by our friend Alex Morley.

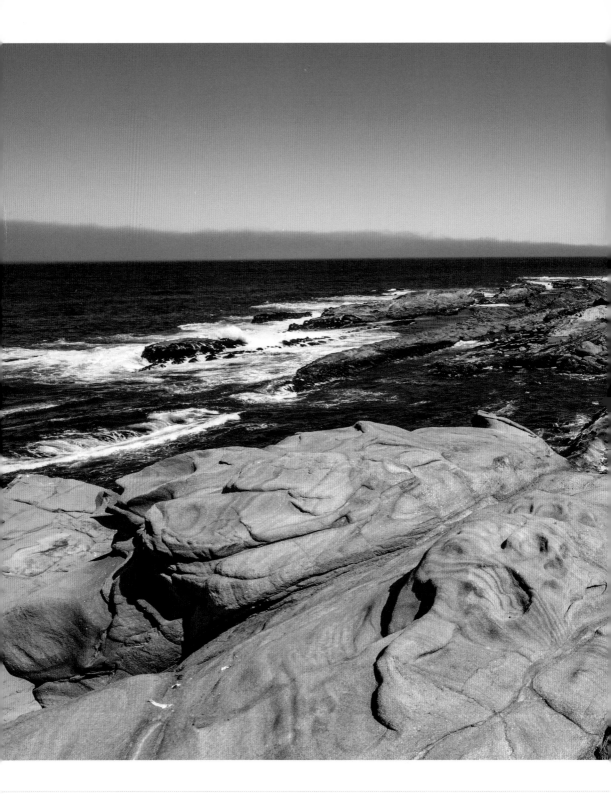

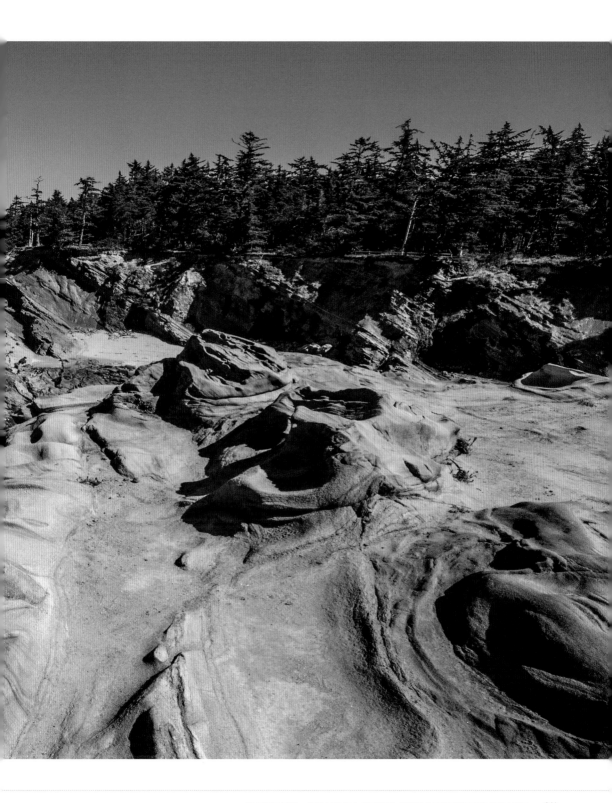

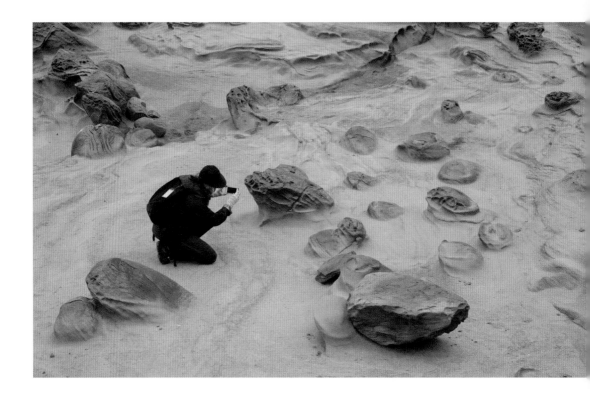

You can start your visit in the gardens or on the rocky bluff. The bluff offers a walk along the top of the rocks and another walk along a sheer wall below. Our group usually begins our visit on the bluff, which offers a spectacular view of the Pacific Ocean as well as countless close-up photo opportunities.

Here is a shot of Susan making a close-up picture of the out-of-this-world landscape. If she had been wearing a space suit costume, she would look like she was on the moon!

After exploring that area, we move to the wall, referred to by some as Minor White's Wall because the famed photographer Minor White brought his students here to practice composition—which is the same reason we come here year after year.

The pair of images on the following page shows a section of the wall and a much tighter view of the same scene. Most people who look at the bottom image see the logo of the Seattle football team, a sea hawk. See what we mean about a photographer's wonderland!

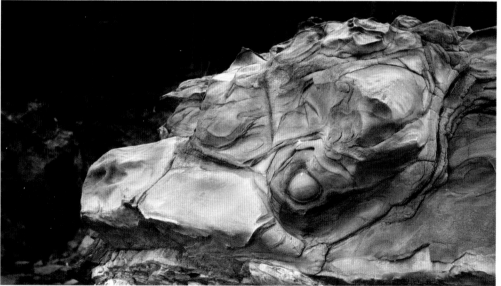

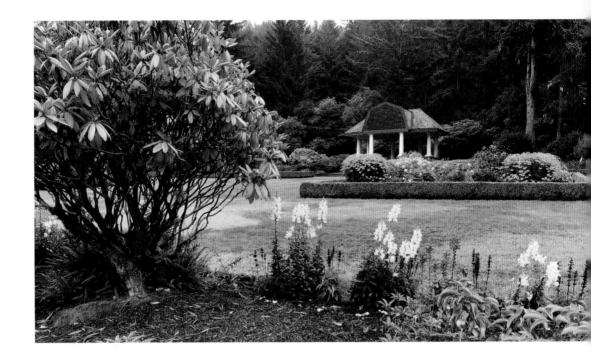

If you like visiting and exploring gardens, you've come to the right place. Here you will find a formal garden, a Japanese-style garden with a lily pond, a rose garden, and more. Of course, different flowers bloom at different times of year, so you may want to call ahead or check the park's website to see what is in bloom.

Due to the welcoming layout of the gardens, you can get close to the flowers for wonderful close-up photographs.

Shore Acres State Park
89039 Cape Arago Hwy.
Coos Bay, OR 97420
(541) 888-3732

Photo Tips

Seek out patterns: While exploring the sandstone area, look for and photograph patterns and formations that you recognize. On the left we see a humpback whale breaching, and on the right we see a wave pattern. What do you see?

Get up close: Here is another creative close-up. We see a lion guarding the rock wall. The photo opportunities here are endless.

When it comes to composition, dead center is deadly—usually. But as you can see in the photo on the left, placing the subject in the center of the frame works perfectly. The picture on the right shows the subject off-center, which is usually—though, again, not always—a pleasing composition.

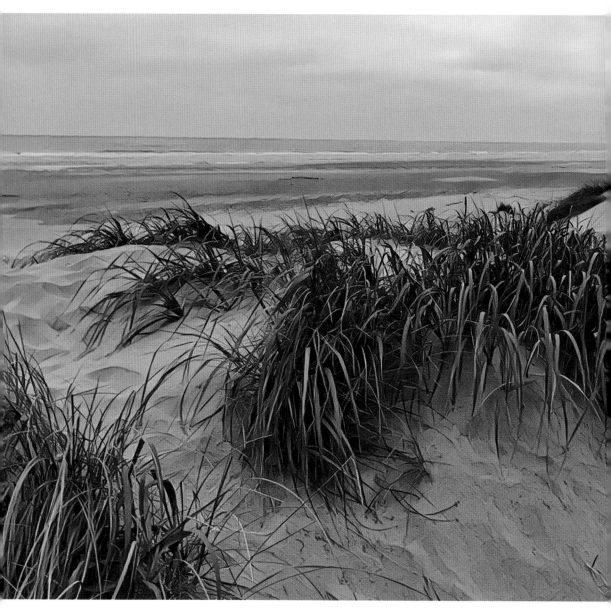

Oregon Dunes

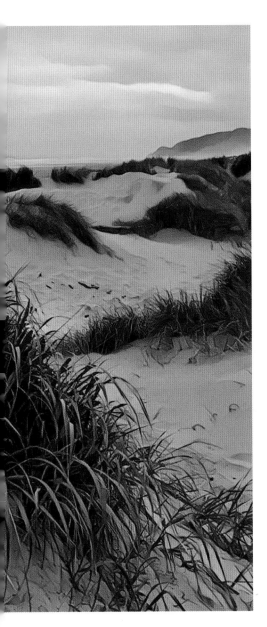

Oregon Dunes and Overlook

Ocean waves are not the only waves on the Oregon Coast. Sand dunes dotted with sea grasses and featuring ever-changing wind-blown patterns are a big part of the coastal landscape.

You can find sand dunes in many locations up and down the coast. The Oregon Coast has more than forty miles of dunes, the largest expanse of coastal dunes in North America. We recommend a stop at the Oregon Dunes Overlook. It's right off US 101, about eleven miles south of Florence. A stop here to photograph the dunes will add variety to your coastal photo collection. There are great views of the dunes and the Pacific Ocean from an elevated deck. If you have time, you'll also find access to hiking trails that weave through the forest and dunes.

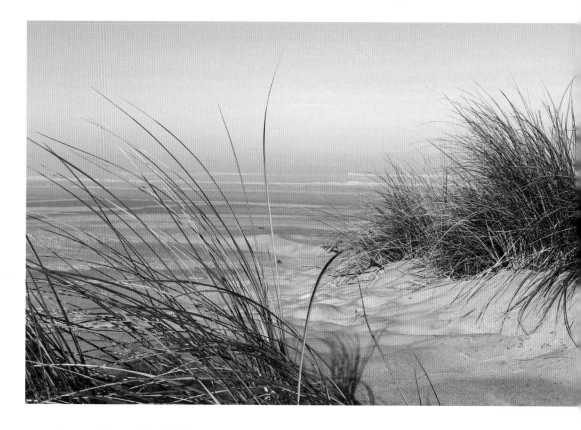

Oregon Dunes Overlook
US 101
Gardiner, OR 97441

Photo Tip

Coastal scenes are a favorite among painters—and photographers. Here Susan used one of her artistic apps, Glaze, to create this painting-like effect.

Bandon Stay and Eat

LODGING

Sunset Oceanfront Lodging
1865 Beach Loop Rd.
Bandon, OR 97411
(541) 347-2453
Best place to stay for photographers, with private beach access overlooking Face Rock.

Best Western Inn at Face Rock
3225 Beach Loop Dr. SW
Bandon, OR 97411
(541) 347-9441
Newer property with comfortable rooms close to the beach.

RESTAURANTS

Tony's Crab Shack
155 First St. SE
Bandon, OR 97411
(541) 347-2875
Highly recommended for lunch or dinner. Busy place with amazing food and outdoor seating.

Lord Bennett's
1695 Beach Loop Dr. SW
Bandon, OR 97411
(541) 347-3663
Excellent seafood and good wine. Fine dining with ocean views. Next to Sunset Lodging.

An Oregon Coast classic: fish tacos. Great for lunch, dinner, or anytime. We love 'em at Tony's Crab Shack.

Bandon Coffee Café

365 Second St. SE
Bandon, OR 97411
(541) 347-1144
Friendly neighborhood spot. Great coffee,
bagels, and breakfast sandwiches.

ON THE WAY

Pancake Mill Restaurant

2390 Tremont Ave.
North Bend, OR 97459
(541) 756-2751
On the way from Florence to Bandon. Good lunch
stop and marvelous muffins to go.

Homemade baked goods are just *one* reason why the Pancake Mill Restaurant is
always busy. It's worth the wait!

INDEX

Page numbers in *italics* refer to captions.